W9-BNG-508

11,782

TR
147 Time-Life Books
.T45 Frontiers of
 photography

DATE DUE

Frontiers of photography
TR147.T45 11782

Time-Life Books
 VRJC LIBRARY

Bt
6.47

Frontiers of Photography

TIME
LIFE
BOOKS
®

Life World Library
Life Nature Library
Time Reading Program
The Life History of the United States
Life Science Library
Great Ages of Man
Time-Life Library of Art
Time-Life Library of America
Foods of the World
This Fabulous Century
Life Library of Photography
The Time-Life Encyclopedia of Gardening
The American Wilderness
Family Library
 The Time-Life Book of Family Finance
 The Time-Life Family Legal Guide

LIFE LIBRARY OF PHOTOGRAPHY

Frontiers of Photography

BY THE EDITORS OF TIME-LIFE BOOKS

TIME-LIFE BOOKS, NEW YORK

© 1972 Time Inc. All rights reserved.
Published simultaneously in
Canada. Library of Congress catalogue
card number 72-77412.

ON THE COVER: In the beginning, in 1968, this picture was a multiple exposure in color of a wedding party in the gardens at George Eastman House in Rochester, New York. About a year later photographer Tom Porett printed the transparency onto high-contrast black-and-white film, painted over some details, then printed the touched-up negative on another sheet of high-contrast film. While developing this positive, he flashed a light on to reverse some tones and create the hard line edging. Next he painted over portions of the positive and copied it onto color positive film. From what remains of the original, a member of the wedding might still reconstruct the scene in memory.

TIME-LIFE BOOKS

Founder: Henry R. Luce 1898-1967

Editor-in-Chief: Hedley Donovan
Chairman of the Board: Andrew Heiskell
President: James R. Shepley
Chairman, Executive Committee:
James A. Linen
Editorial Director: Louis Banks

Vice Chairman: Roy E. Larsen

Editor: Jerry Korn
Executive Editor: A. B. C. Whipple
Planning Director: Oliver E. Allen
Text Director: Martin Mann
Art Director: Sheldon Cotler
Chief of Research: Beatrice T. Dobie
Director of Photography: Melvin L. Scott
Assistant Text Directors:
Ogden Tanner, Diana Hirsh
Assistant Art Director:
Arnold C. Holeywell
Assistant Chief of Research:
Martha T. Goolrick

Publisher: Joan D. Manley
General Manager: John D. McSweeney
Business Manager: John Steven Maxwell
Sales Director: Carl G. Jaeger
Promotion Director: Paul R. Stewart
Public Relations Director:
Nicholas Benton

LIFE LIBRARY OF PHOTOGRAPHY
Series Editor: Richard L. Williams

Editorial Staff for
Frontiers of Photography:
Picture Editor: Patricia Maye
Text Editors: Betsy Frankel,
Anne Horan
Designer: Herbert H. Quarmby
Staff Writers: Helen Barer, John Porter,
Suzanne Seixas, John von Hartz,
Johanna Zacharias
Chief Researcher: Nancy Shuker
Researchers: Elizabeth Dagenhardt,
Angela Dews, Helen Greenway,
Lee Hassig, Don Nelson,
Jane Sugden, John Conrad Weiser
Art Assistant: Patricia Byrne

Editorial Production
Production Editor: Douglas B. Graham
Quality Director: Robert L. Young
Assistant: James J. Cox
Copy Staff: Rosalind Stubenberg,
Barbara Quarmby, Ricki T. Schacter,
Florence Keith
Picture Department: Dolores A. Littles,
Gail Nussbaum

LIFE STAFF PHOTOGRAPHERS
Carlo Bavagnoli
Ralph Crane
John Dominis
Bill Eppridge
Henry Groskinsky
Yale Joel
John Loengard
Michael Mauney
Leonard McCombe
Vernon Merritt III
Ralph Morse
Carl Mydans
John Olson
Bill Ray
Co Rentmeester
Michael Rougier
John Shearer
George Silk
Grey Villet
Stan Wayman

Director of Photography:
Richard Pollard
TIME-LIFE Photo Lab Chief:
George Karas
Deputy Chief: Herbert Orth

Valuable aid was provided by these individuals
and departments of Time Inc.: Editorial
Production, Norman Airey, Nicholas Costino Jr.;
Library, Peter Draz; Picture Collection,
Doris O'Neil; TIME-LIFE News Service,
Murray J. Gart; Correspondents Margot Hapgood
(London), Maria Vincenza Aloisi (Paris),
Elisabeth Kraemer (Bonn), Ann Natanson (Rome).

The volumes of the LIFE Library of Photography deal both with the technological nuts and bolts of the subject—how cameras and lenses work, how light interacts with film—and with the nature of the art, showing how great photographers have interpreted great themes. In this book the editors have ventured out to the frontiers—both technical and esthetic—for a look at where photography seems to be heading.

One clear trend is the resurgence of interest in abstraction. While most picture taking is, and probably will continue to be, "straight," a great many photographers are working with non-objective subject matter (or even no subject matter at all) and using every darkroom technique they can think of to produce pictures different from what most people are used to seeing. Whether this is good or bad, an advance for the medium or a corruption of it, is up to the viewer to see for himself.

On the technical frontiers, a lot is going on, some of it fascinating mainly to laboratory scientists from whose domain it may never emerge, and some of it very likely to affect the photography the rest of us do. The future is crowded with new ways to automate picture taking, new imaging systems, new applications of holography, that all-but-occult subscience that already has come up with the spookiest apparitions since the last appearance of Caesar's ghost.

There appears to be no limit to what can be invented—but there is a limit to how much new equipment can go from lab to factory to corner camera store. The limit is economic: if the cost of the dream camera is too high or the demand too low, it will stay in the future until its time comes. But except for the limitations of their own pocketbooks, photographers needn't worry; the new, the different, the better is on the way. On all the frontiers, growth continues.

The Editors

Clues to the Future 1

The shape of a shapely model is plotted with ▶ cartographic clarity in this topographical view of a nude. To make the human map, stereo photographs were placed in a machine that traced the body contours at intervals representing about one-quarter-inch difference in elevation. This mapmaking technique is one of many procedures used in photographing the Thirteen Faces of Susan, a portfolio that begins on pages 18-19.

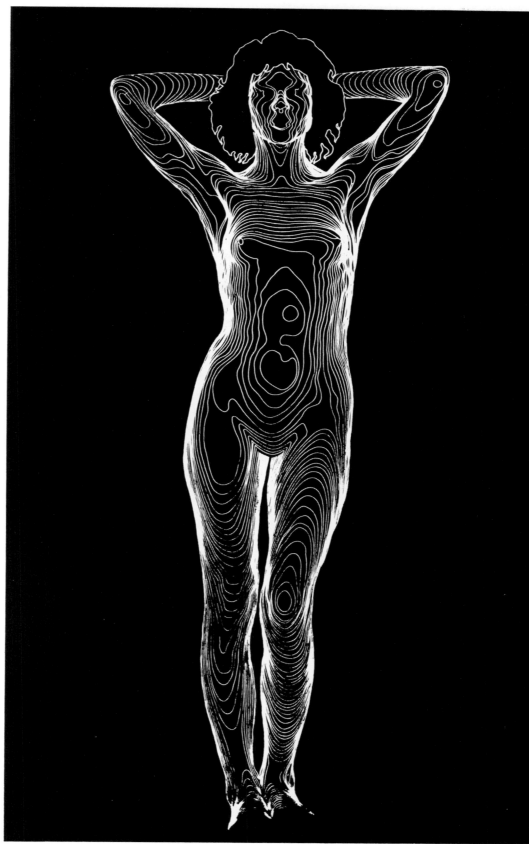

GERHARD NAGEL: *Contours of a Girl in a Stereophotogram*, 1970

Where Does Photography Go from Here?

In 1929, cartoonist Dick Calkins depicted a character in his Buck Rogers comic strip marveling at a finished photographic print that had just processed itself in seconds. A machine that could accomplish such a fabulous feat was, at the time Calkins drew the cartoon, a fantasy suitable for a strip that was supposed to portray events of the 25th Century. Yet in 1947, a mere 18 years after the wild idea appeared in the funnies, Edwin H. Land demonstrated a brand-new device that did exactly what Calkins had envisioned, proving that the cartoonist's fantasies were not so fantastic, and that only his timing was off. Science fiction had become technological fact five centuries ahead of schedule.

The impossible dream is not always overtaken that fast by the accomplished fact. Color photography was invented again and again for almost a century before processes appeared that everyone could use every day. Jules Verne's forecast of a moon trip did not come true for 104 years—and even he could not guess that pictures would then be sent back to earth.

Despite such uncertainties it is possible, if not to predict the future of photography, to examine its frontiers, to see where it seems to be heading in both art and technique. Many new ideas are evident—intriguingly automated cameras, strange kinds of films, radical concepts in picture creation —and they suggest broader changes that are to come.

That photography changes rapidly is clear from a glance backward over recent decades. Since World War II it has boomed as pastime, hobby, art and profession. The figures alone are impressive. In two decades the number of pictures taken by amateur photographers in the United States more than tripled and the proportion of those that were color pictures went up five times. Amateurs now spend close to three billion dollars a year on photography. Many high schools offer classes in photography—for scholastic credit, not as after-hours extracurricular activity—and by 1970 college-level courses in photography were being offered in some 700 institutions of higher learning.

A trend to automation

Partly the cause, partly the effect of this great expansion of photographic activity has been an equally rapid development of new apparatus—simpler to use, more versatile, capable of clearer pictures. Before World War II, the ordinary man's camera was a box camera. It was quite easy to work, but so rudimentary its usefulness was limited. It took pictures only in bright light (lens and film were slow), of subjects standing still (the shutter had one speed, also slow), at a medium distance (the lens could not be focused for close-ups). The film, balky to thread into the mechanism, had to be left at the drugstore for a week to be processed. Everyman's camera today is even easier to manage, but it is no rudimentary instrument, for ingenious tech-

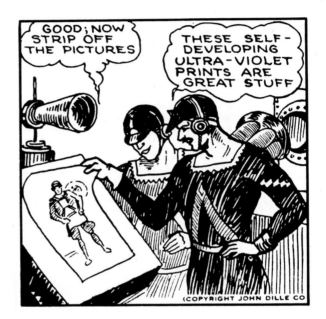

Buck Rogers is somewhere out in space, and at headquarters they need his picture in a hurry. So Buck beams one back to home base via ultraviolet television, to be self-developed and peeled off in seconds. The instantly processed picture was nothing more than 25th Century science fiction when this comic strip appeared in 1929, but it became reality less than two decades later.

Dr. Edwin H. Land, shown here in his laboratory, is perhaps the most imaginative of modern innovators in photography. The brain behind some 400 patented ideas—among them Polaroid plastic for use in glarefree sunglasses and the Polaroid Land cameras that produce pictures in seconds—he believes that the most revolutionary developments in equipment are yet to come.

nological developments have given it versatility without complicating its operation. Fast lenses, fast films and compact flash units coupled with adjustable shutters stop rapid action and get good exposures under any conditions—yet make a photographic system hardly more difficult to adjust than the old box camera. Exposure meters are built in, and many of them make the necessary settings automatically. Threading and double-checking the loading of film is no longer inescapable, because many cameras, including the new, slenderized Kodak Instamatics, take ready-loaded cartridges. And the processing gap is only a memory for those who use Polaroid Land film.

But for serious amateurs and professionals, one of the most meaningful technical developments of recent decades has been the 35mm single-lens reflex camera. It is not a new invention, but it has won widespread popularity only since World War II. Because it is small, it is fairly light in weight, uses economical film, and can have very fast, interchangeable lenses. (Lens speed is related to picture size.) And with these conveniences comes an asset that many creative photographers value highly: the image can be composed and focused through the taking lens, just as with a view camera.

The SLR, good as it is, suffers some obvious defects. Getting a picture with one requires a series of steps. The photographer must select a lens, load the camera, set it for the film's ASA rating, compose the subject in the viewfinder, focus the lens, adjust the shutter speed and aperture, cock the shutter, and at last, press the button. Then comes the processing gap.

The future of the SLR

How this routine might be simplified for the ubiquitous SLR is perhaps the easiest of future photographic innovations to guess at. For one thing, many improvements that have appeared in one form or another on other types of cameras have yet to be added to the most popular makes among the SLRs. Most SLRs already have built-in exposure meters, and on many the meters are coupled directly to the lens aperture or the shutter for automatic setting, but on no one camera does the meter set either lens or shutter (or both together) at the user's option. A few SLRs have been designed to take film cartridges, but the higher cost of film in cartridge form has discouraged some serious photographers, who consume rolls in quantity. And no 35mm camera can yet produce pictures in a minute. The reason is not any special difficulty in building a fitting that would adapt Polaroid Land film to existing 35mm cameras. The problem is the 35mm size—contact prints from it are so small they are not generally useful. What is needed is not so much an instant picture as an instant enlargement. Would such a thing be possible? Apparently it would, the research scientists hint. They do not say how it might work, but some guesses are possible. Perhaps, for example, the printing paper could

be made of materials that expand as they dry. Then the picture would stretch to the desired size before the photographer's very eyes.

Other defects of the SLR are more troublesome to get around. Despite the small size of this camera, it is still larger and heavier than photographers would like. An SLR with a normal 50mm lens weighs about two pounds. A few additional lenses, a tripod and film supply can create a burden of 20 pounds. Changing lenses requires care and attention, and the possibility of dropping one, or even of knocking it against a doorjamb raises visions of dollars dumped into a trash can. Problems like these are not to be solved simply by bringing together scattered improvements that, in one form or another, are being sold already. New ideas, not now on the market, are needed.

A dream camera

Clearly the technology of photography has a way to go before reaching its limits. But are there any limits? Polaroid's Dr. Land would say no. "Nothing you can imagine," he says, "is technologically unfeasible." Recently he encouraged a visitor in his book-lined laboratory office to spin a fantasy about a dream camera. Tempted by the prospect of freewheeling without a practical care, the visitor proceeded: perhaps the ideal camera would be the size of a billfold. It would have all the automatic and electronic devices of today's most advanced cameras, yet it would be indestructible; and all its controls could be operated manually if the photographer preferred. Instead of an array of costly lenses, its "eyes" would be the size of coins, all mounted on a single, movable unit, and made of a material that could withstand heat, impact and pressure. These lenses would, of course, demand grain-free films so fast they would never require artificial light. An instant developing and printing system could be used inside or outside of this dream camera, but it could be bypassed if the photographer preferred to exercise control in the darkroom. And why not an all-purpose film—from which his camera or his home developer could turn out negatives, transparencies, prints in either black-and-white or in perfect, faithful color? They would be self-enlarging prints that would expand of their own accord—at least until the photographer signaled them to stop. Is all this a ludicrous fantasy? "Not at all," said Land. "In fact, it's conservative."

The billfold-sized supercamera seems conservative to Land because developments that could make it come true are even now being tested. How some of its features could be provided is fairly easy to imagine. Very small size in mechanical parts, for example, can be achieved if the demand warrants. Fully automated controls could be achieved by adopting existing devices—today there are even mechanisms that adjust focus automatically *(pages 40-41).* When it comes to small lenses and the triple- or quadruple-

purpose films that are stipulated for the billfold camera, reality is further off. Such improvements would not be refinements of present types of lenses and films, but basically different types. A few are already in the works.

Curveless lenses

Scientists already have given thought to flat lenses, solid disks of glass that could do anything expected of today's assemblages of multiple, curved elements. The secret of such lenses would lie in their materials: the composition of the glass, not the shapes of surfaces, would control the focusing of light rays into an image. Any lens creates an image by changing the direction of light rays. Rays that had been spreading apart after they were reflected from the subject are bent so that they come together again, reconstituting the appearance of the subject in its image. The bending effect occurs because light travels more slowly in glass than in air; when a ray enters (or leaves) glass at an angle it is turned by its change in speed. How much and in which direction the ray bends is determined by the speed of light in the glass and the angle at which the ray strikes the glass surface.

These factors are the only ones the lens designer has to work with. He can control the angle between light ray and glass by his choice of the contour of the glass surface, and control the speed of the ray by his choice of glass type, since the speed of light varies with glass formulation (it is indicated by a quality called refractive index).

Until now the contour of the glass has been the principal factor used in planning lenses. The designer first chose a glass having a suitable refractive index, then varied the surface contours until he got the desired degree of light-ray bending. But to achieve more bending—to correct optical errors or to produce a specific type of image—additional pieces of glass, or elements, were needed. Most good camera lenses have at least three elements; some have a dozen or more and therefore must be fairly long and heavy.

The need for multiple elements could be eliminated if refractive index could be varied as easily as a surface contour. Within a single element, gradations in the index would bend light rays first one way, then another, to realize the designer's objective. One method of producing such controlled variations within glass has been explored in French atomic energy laboratories: bombardment with nuclear radiation. If this were pursued to success, the long, heavy multielement lens could be replaced by a single element.

The revolution in film

The second fundamental change that such a supercamera calls for is in the film. For more than a century, photography—black-and-white, color, even the instant picture process—has been bound to chemical imagemaking sys-

tems based on compounds of silver. They have served the medium well, being capable of producing great subtlety of tone and hue, and above all, of recording an invisible (latent) image that, through development, can be amplified up to a hundred million times or more. That is, for every molecule of silver compound that registers an impression of light, chemical development releases 100 million atoms of pure silver—the process that makes the latent image visible. But silver systems demand multistage processing that is usually messy and time consuming. Besides, silver, of which photography in the United States uses about 35 million ounces a year, exists in limited quantity and is costly. So the major change in film may be new imaging systems that function on principles employing only a little silver or none at all.

The chemists' objective is not merely to replace silver but to eliminate or shorten the time lag between the release of a shutter and the delivery of a finished, visible picture, preferably without chemical processing. Such rapid, direct imagemaking is already possible with the television camera, with electrostatic office copying machines and with certain microfilming processes, such as one employing tiny bubbles of nitrogen gas. Such methods, described in Chapter 3, gain their speed and simplicity because they rely more directly than do silver-based films on electrical effects of light.

Erasable electronic images
Silver films, while seeming to be purely chemical in their action, actually respond to light with a change in their internal electrical characteristics. Light energy, striking a molecule of silver compound, energizes a particle of electricity—an electron—within the molecule. The energized electron may then join with the silver atom in the compound, freeing that atom to become pure silver metal. Many other substances, particularly oxides of metals like zinc, are affected in a somewhat similar fashion by light. When a lens focuses an image on such a substance, electrons within it are energized, creating electrical charges on the surface in a pattern that corresponds to the lights and darks of the optical image. This electrical charge pattern can then be made visible in a number of ways. In a TV camera it is scanned by an electron beam to convert it into electronic signals for the picture tube of a television receiver. In an office copying machine, the charge pattern can be produced on oxide-coated paper, and it attracts black pigment; the pigment sticks to the paper where no light has struck and does not stick where light has struck. One new ceramic "film" *(page 56)* reveals its image when given a jolt of electricity and erases itself when subjected to a flash of light and another jolt.

The development of such methods, so far removed from image-recording processes of traditional photography, suggests that the supercamera of the future may not even use film as we know it. Conceivably the camera could

contain a permanent sensitive plate that records images and erases them the way tape recorders record and erase sound. It might be loaded with plain paper. After exposure, prints could simply be pulled out.

New technology, new art

If the apparatus of photography changes so radically, will the pictures it makes change equally? Different they certainly will be, for technology has always influenced artistic direction. A daguerreotype is easily distinguishable from a modern portrait, and even J. H. Lartigue's turn-of-the-century scenes, made on large glass plates, have a quality different from a slice-of-life caught by Henri Cartier-Bresson's 35mm camera. In fact, it is generally the artist who presses the inventor rather than the other way round. The artist's creative needs often demand more of technology than it can deliver.

Already this straining at technological bounds can be seen in the work of avant-garde photographers. Many of them, bored with the precise recordings of reality so easily made with today's equipment, have turned to abstractions *(Chapter 6)*. They use ordinary cameras and ordinary techniques to distill reality, often distorting images beyond recognition. Others combine all kinds of technology, old and new, with the traditional processes of photography *(Chapter 3)*. They employ draftsmen's duplicating materials, lithography, silk-screen printing, photoengraving and every other image-making material. The results embody such varied techniques that they are not always recognizable as photographs—many of them, indeed, are the creations of artists who count themselves painters or sculptors. Yet at the basis of each is some form of photographic image.

The marvelously diverse work that even now is to be seen on the frontiers of photography says something reassuring about what lies beyond the horizon. In a future that promises to be full of moving pictures—instant color cinema, instant-replay TV tapes for the home tube—many experts have seen the end of the still picture. Their epitaphs, like the one Marshall McLuhan composed in 1962 for the printed word, seem premature. Indeed, it is likely that these experts are just plain wrong. They overlook the fact that the still picture, like the word that holds still in print, has properties that give it enduring strength. While a motion-picture frame appears on the screen and is replaced by another in 1/24 second, a still provides infinite opportunities to re-examine and reflect, and limitless time to contemplate the photographer's intent and his result. No moving images can ever supplant still photography's unique function as a medium of precise documentation. No war, no crime, no loving glance can ever be depicted with greater force than with the single sharp still photograph that strikes the eye and mind like a smart slap on the cheek. This medium too "is the message," and it will last. □

Thirteen Faces of Susan

Pretty girls have been a favorite subject for picturemakers as long as there have been pretty girls. But there probably has never been a set of pictures quite like the "faces" of a young Swedish actress shown on page 11 and the following pages. In this remarkable album she appears as a multicolored skull, a study in topography, a scattering of light waves, a bit of skin seen through a scanning electron microscope, a disembodied voice, an ultrasonic study, a pattern of stresses, a heat-wave profile and a phosphorescent night person. The reclining pose on the facing page makes use of ordinary visible light, but her image, or some form of it, has been captured by the use of several different forms of electromagnetic energy, including sound waves, thermal waves and invisible but powerful X-rays.

The album was conceived by Dieter Lübeck, formerly the editor of the German popular science magazine *X*, as a means of dramatizing some of the more advanced techniques in image-making. Entitled "The Total Portrait: Susan," it was first exhibited at Photokina, the international photography show in Cologne, and later was published in *X*.

Altogether Lübeck and his model, Marianne Blomquist, renamed Susan for purposes of the project, spent six months visiting 14 different research centers and used the services of 31 author-photographers to assemble the material. The areas of science into which they ventured bear such mouth-filling names as light intensification, photoelastic stress analysis, scanning electron microscopy, ultrasonic image conversion, X-ray equidensity, holography, sonography, thermography and stereophotogrammetry. Fortunately the pictures are easier to understand, even if Susan could hardly recognize herself in most of them. Though ultimately they are important for the insights they provide into once-unexplored facets of the physical world, they also can be enjoyed simply for their visual impact. In these strange and unearthly images Susan is revealed as both more and less than a pretty girl.

Susan, the patient young subject of the portfolio ▶ of unconventional portraits on the following pages, reclines on a winter's worth of firewood at her hometown of Värmland, Sweden, in a more-or-less conventional pretty-girl pose.

VERNON REGIONAL
JUNIOR COLLEGE LIBRARY

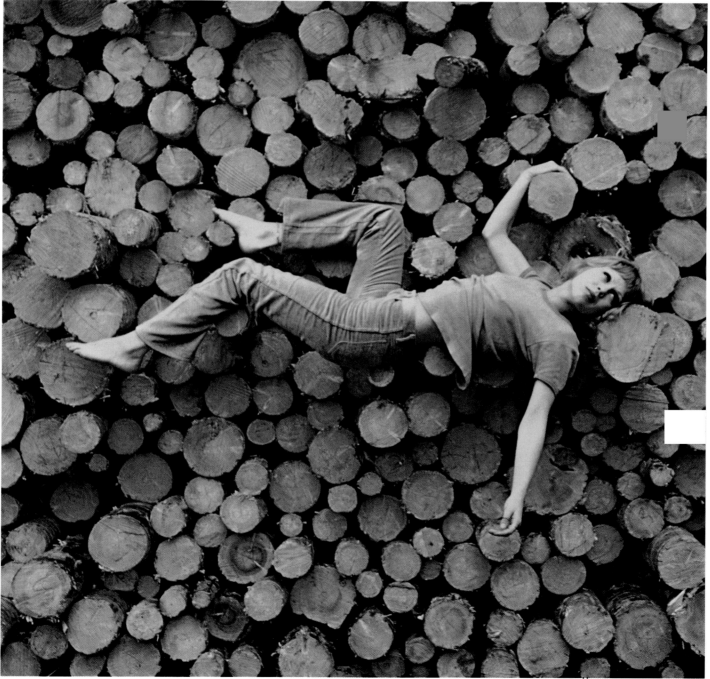

DIETER LÜBECK: *Susan at Home*, 1970

19

To get inside Susan's head for these intricate color portraits of her skull, medical technicians took an ordinary X-ray picture and subjected it to two copying processes designed to highlight details of the X-ray. First, they reduced the number of grays in the picture, isolating the remaining grays into areas of equal density; then they recopied each area on colored film.

Most of this transformation from hazy black-and-white to sharply defined color was accomplished automatically by using two special-purpose films. One, called equidensity film and made by Agfa-Gevaert in Germany, is essentially a darkroom tool. It records only a single tone of gray at a time; that tone comes out blank, while all darker and lighter tones are reproduced as solid black. The exposure time determines which tone becomes clear. Consequently, successive copies at different exposures provide images with different areas, or contours, of gray. Several such high-contrast copies were made of Susan's X-ray, and each of the various contoured areas was then recopied in a single color. For this, the second special film was used, a transparent copying film designed for making color copies of black-and-white material; the film comes in eight colors and prints by being exposed to heat, in any thermal copying machine. Susan's color-coded contours were then put together into a multicolor X-ray.

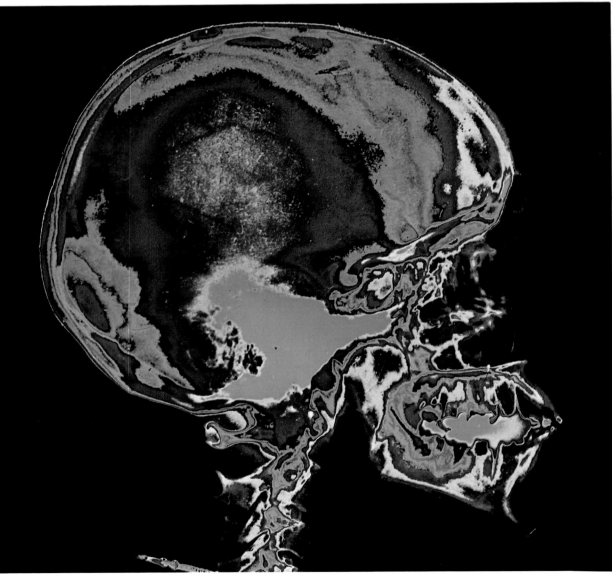

ERHARD BORCKE, ERWIN RANZ: *X-ray and Equidensity,* 1970

If Susan's X-ray were being transformed into color for a medical examination, technicians would introduce the hues so as to give a distinctive shade to each detail in the area under study. Here, there is no such serious purpose. In the picture at left the least dense areas have been reproduced in light blue, the densest areas in red, and the intermediate areas of thin bone and cartilage around Susan's face and spinal column in darker blue. In the picture at right the corresponding areas were arbitrarily assigned the colors of pink, yellowish green and purple.

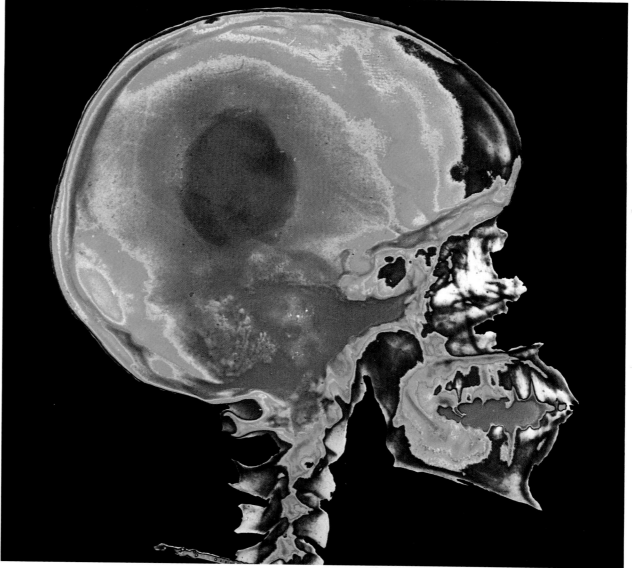

ERHARD BORCKE, ERWIN RANZ: *X-ray and Equidensity,* 1970

Susan as seen by two mapmaking techniques is a study in topography: in one *(far right)* her features are reduced to lines indicating changes in elevation like the lines on a contour map; in the other they are reconstructed in three-dimensional relief.

Both versions are end products of stereophotogrammetry, by which variations in the earth's surface are charted from aerial photographs. The photographs, taken in pairs from slightly different positions, are placed in a drafting machine called a stereoplotter, a very complex modern version of the old-fashioned stereoscope *(pages 126-127)*. The plotter picks out areas of equal elevation and transcribes their boundaries into a contour drawing.

Using the contour drawing as a template, a second device called a milling machine (somewhat like the machines that cut duplicates of keys) can convert the information into a gypsum model. So delicate are the responses of the milling machine that it can reproduce three-dimensional objects to extremely fine tolerances. Once, to demonstrate its ability, technicians used this complex process to make a facsimile of the head of Nefertiti, the 14th Century B.C. Egyptian queen. In Susan's case the reconstruction is much less refined—the intervals between contours in both portraits are set at five millimeters, roughly one quarter inch—reducing her face to a series of planes.

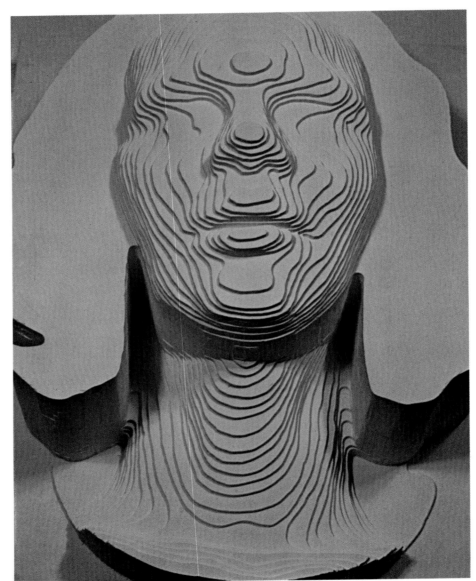

KLAUS LINKWITZ, HANS PREUSS: *Study in Relief,* 1970

Susan's contour model (above) and contour portrait (right) demonstrate how specialized forms of cartography may be used for more than mapmaking. The techniques are being employed experimentally to study differences in human body types and growth patterns, and to determine if, for example, there is a measurable relationship between physique and mental retardation.

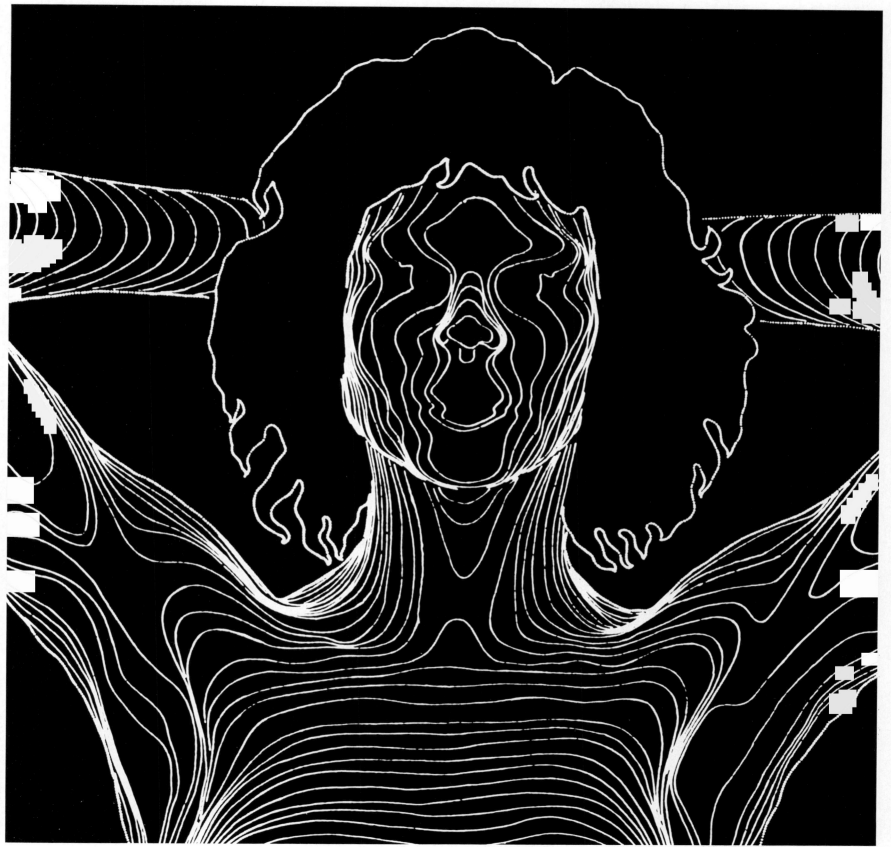

GERHARD NAGEL: *Stereophotogram,* 1970

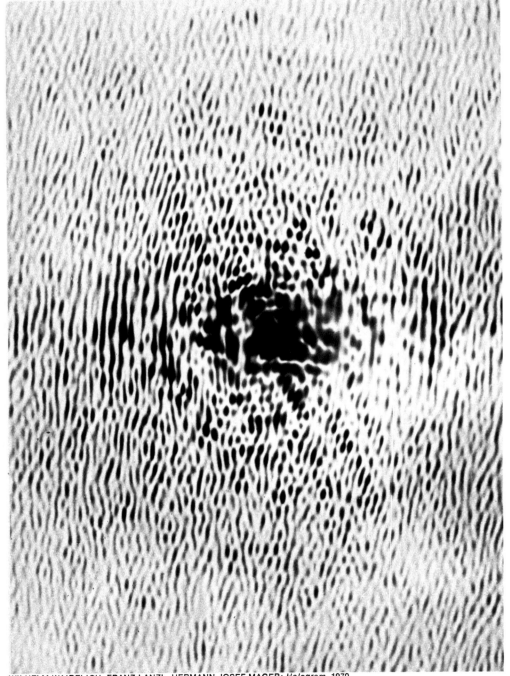

The pattern of light waves at left and textured hillocks at right are parts of Susan's face examined in detail and in extraordinary dimensional depth, respectively. Such searching views of a subject are made possible by two relatively new examining agents, the laser —an intense beam of light—and the scanning electron microscope.

The picture at left, produced by holography *(pages 134-158),* is a sort of scrambled message which, when projected by proper equipment, becomes a likeness of Susan's face. Both the coded picture shown here and the projection are done by laser beams.

The picture at right, formed with the scanning electron microscope, explores one small area of Susan's chin, magnified 500 diameters. The scanning microscope sends a beam of electrons, tiny electrically charged particles of matter, to and fro over the surface of a subject, exploring its contours to give an enlarged view of great clarity. Since the beam must travel in a vacuum, it could not be used directly on Susan's face. It actually examined an impression of her skin in plastic that was gilded to make it reflect electrons.

Susan's hologram was composed by splitting a single laser beam in two. One part of the beam was reflected off a photograph of Susan's face before going toward the film; the other part—the reference beam—was deflected by mirrors directly toward the film. The pattern created on the film by the converging beams can be reconstructed into the portrait of Susan simply by passing a single laser beam through it.

To the scanning electron microscope, Susan's ▶ chin is hillocked terrain cut by crevices, with a hairlike wisp of dirt in the center. The image, generated by electrons rather than light, was translated into a visible picture on a TV-like screen and the TV image was then photographed.

WILHELM WAIDELICH, FRANZ LANZL, HERMANN JOSEF MAGER: *Hologram,* 1970

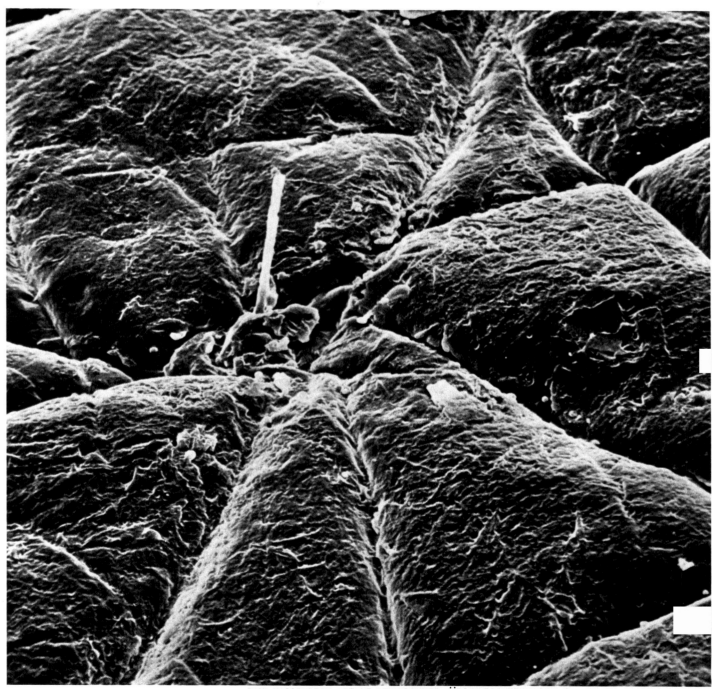

PAUL KASSENBECK, ARTHUR NEUKIRCHNER, JÜRGEN TOCHTENHAGEN: *Scanning Electron Micrograph*, 1970

FRITZ WINCKEL, MANFRED KRAUSE: *Sonogram*, 1970

The audible sounds of Susan's voice and the inaudibly high-pitched sounds of ultrasonic waves passing through her index finger supplied the energy in turn for the sonogram, or voiceprint, above, and the "sound picture" that looks somewhat like an X-ray on the facing page. The sonogram is produced by an instrument that separates words into their component sounds and analyzes each sound for its volume, resonance and pitch. Even allowing for variations in Susan's voice, the device would invariably pick up the sound patterns that were uniquely Susan's.

Sound pictures are made by directing a beam of high-frequency sound through the subject under examination —usually in water, for water carries sound well. The sound waves emitted by the subject, varying in intensity with the nature of the material they pass through, are collected by an instrument that converts them into electrical impulses. These in turn create an image on a TV screen for immediate study or for photographing.

JOHN L. DUBOIS: *Sound Picture*, 1970

◄ *The sonogram at left of Susan saying "du" and "ja" (Swedish for "you" and "yes") is a visual representation of the sounds made by her voice. The span of the striated curve, left to right, registers the duration of a sound; the vertical distance from bottom to top of the sonogram registers pitch; and the darkness or lightness of the striations indicates greater or lesser volume.*

A picture of Susan's index finger revealed by ultrasonic waves resembles a standard X-ray except for the colors. The large black area is the finger bone. The areas around it show up in different colors because differences in tissue characteristics affect sound absorption, and these variations are converted into colors by methods like those that create color television.

ROBERT K. MULLER, ROLF KAYSER: *Weight Portrait,* 1970

The pressure of Susan's foot on a block of plastic and the heat generated by her head produced respectively the portraits of her weight at left, and of her temperatures at right. One depends on a technique used by engineers to study stresses within a structure; the other, on a device used in detecting cancer.

The weight portrait exploits a characteristic of transparent plastics: when under pressure they alter the polarization, or plane of vibration, of light waves. This rerouting of light is ordinarily invisible to the eye, but when viewed through a complex lens-and-filtering system called a polariscope the rerouted light shows up as colored patterns from which experts can gauge both the amount and direction of the stress.

The heat portrait, or thermogram, was made with the help of a detector that converts radiated heat waves into a TV-like signal, and registers areas of uniform temperature on a screen. In Susan's case the hottest part of her head, her forehead, and the coldest part, the back of her neck, represent a temperature range of only 3°C. Each color contour in her thermogram marks a 1° variation in temperature.

The glowing color patterns in the plastic slab beneath Susan's foot provide a sort of picture of her weight. Known facts about the plastic—its dimensions, density, characteristic response under pressure to light rays—enabled technicians to calculate that Susan weighs 115 pounds.

Like shadows across her face, radiant heat ▶ emanating from Susan forms thermal contours plotting uniform temperatures (right). The contours appear as black-and-white images on a TV-like screen and are photographed in successive exposures through filters, a different color for each contour. Each color thus indicates one temperature: the colors, ranging from hot to cool, are white, yellow, red-orange, violet, green and blue; black areas between colors are intermediate temperature zones.

DIETER VÖLKER: *Thermogram*, 1970

Susan in pitch dark is photographed off guard by a hidden camera that sees in the blackness of night and emits no tell-tale flash to betray its presence. The heart of the "Owl Eye" is a scope about 19 inches long, with a lens at one end and a viewing screen at the other. Within the scope an image intensifier collects whatever light is available and amplifies it thousands of times; the light is then converted to electrical signals that activate a phosphor screen to present a visual image.

In Susan's case the system used has a light intensification factor of 1:12,000 —enough to enable an area of 100 square feet to be seen from 100 yards away by the light of her cigarette. More powerful models intensify light 150,000 times. Developed for use by the United States military in Vietnam to enable GIs to observe the Viet Cong at night undetected, the Owl Eye is now employed by law enforcement agencies in crime detection and search and rescue operations. With its help police have caught burglars at work, shadowed suspected drug pushers and monitored the transport of stolen goods. In California, the equipment enabled a sheriff's posse to locate a lost boy in the San Gabriel Mountains after dark.

Susan's ghostly green image, photographed from the Owl Eye's display screen, is actually four times more detailed than the image on an ordinary television screen. At $6,500, the device is hardly standard photographic equipment but once owned it is cheap to operate: a bank of three flashlight batteries will power it for 24 hours.

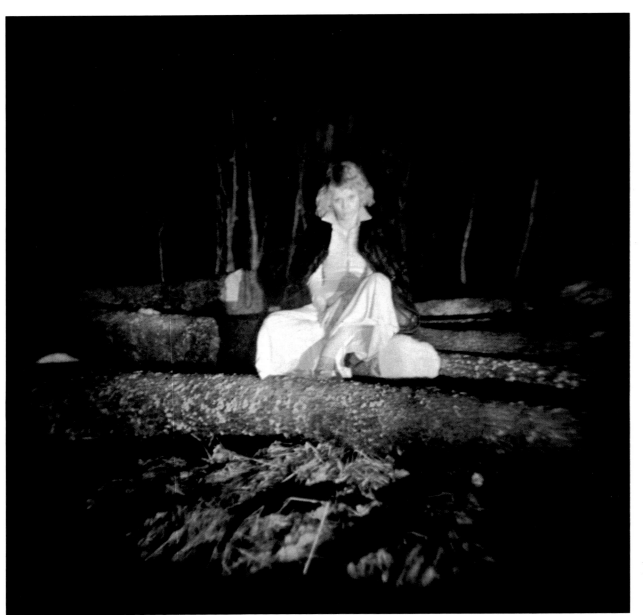

POLICE BUREAU OF STUTTGART: *Owl Eye View,* 1970

Cameras in the Computer Age 2

The Impact of Automation 34

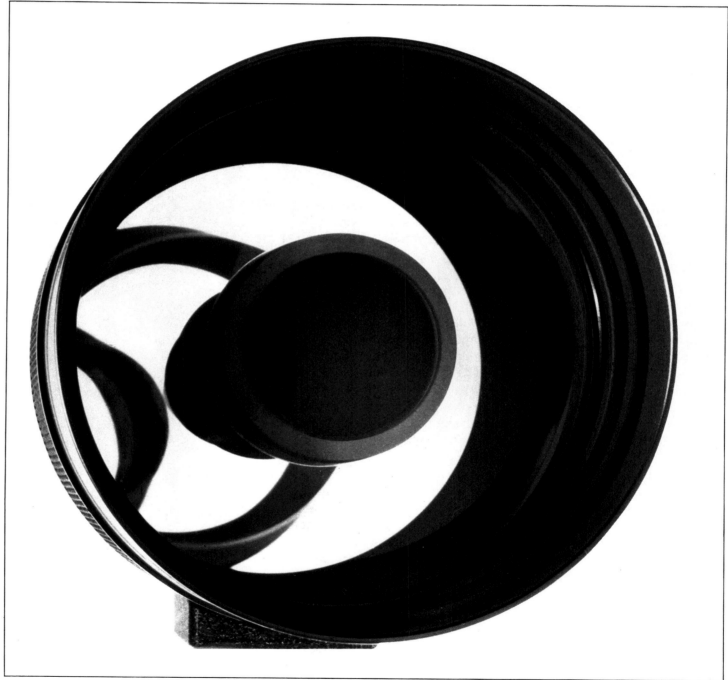

AL FRENI: *Looking into a Mirror Lens,* 1972

33

The Impact of Automation

Joseph Nicéphore Niépce, the French inventor who took the world's first photograph, certainly would be gratified to see how cameras and lenses have improved since 1826. And yet, not until recently would Niépce have been really amazed. For nearly a century and a half camera systems changed very little, except to get smaller and simpler to handle; they evolved predictably from cumbersome, handmade, manually operated devices into more compact versions with greater precision and mechanical controls. To-day, however, photography has entered a wholly new era—that of electronics and automation. Equipment now available and designs still on the drawing boards portend future developments that Niépce and other pioneers could never have predicted.

The new era began in the 1960s with the arrival of the cadmium sulfide (CdS) exposure meter. This instrument, powered by tiny batteries so that it could take advantage of the extreme sensitivity of the CdS cell, is far more accurate than earlier light meters and at its best can provide a reading by the light of the moon. It was only a short step further to build the meter into the camera itself; when that happened, the first glimmer of automation came with it, for now the photographer could gauge exposure while he was com-posing and focusing his scene. (On highly refined cameras, a mechanical linkage permits focusing with the lens wide open after exposure has been set—pressing the shutter button automatically closes the aperture to the preselected f-stop.)

This system is still manual, however, because the photographer first has to handset the shutter speed and the aperture and then readjust one or the oth-er—or both—after taking a meter reading. Automation really arrived with the development of electronic devices that set the camera's controls. These devices are in effect miniature computers. Now the photographer needs to make only one setting, either the shutter speed or the f-stop, depending on the type of camera he is using *(pages 38-39)*. When he presses the shutter button the computer takes over, reading the meter and automatically setting the camera's other control.

But why must the photographer bother setting any exposure controls? Cannot both shutter and aperture be automated in the same camera? The answer is that they can be, and before long they will be. Such complete ex-posure automation is likely to come first in inexpensive cameras designed for the mass of people who take only occasional snapshots of family and friends. Such a picture-taker cares little about photographic technique but wants a clear shot each time he presses the button. The camera for him, in the not-too-distant future, will require only that he set a dial indicating the speed (ASA rating) of the film he is using. Computers will then select the fast-est shutter speed (to stop motion) and the smallest aperture (to provide

depth of field) that can be combined under prevailing light conditions. When he presses the button, the camera will do the rest. Like some cameras already available, this one will have a warning signal—such as a moving needle or a blinking light—to alert the photographer when there is not enough illumination to take a picture. Eventually even this signal will be unnecessary because a built-in electronic flash will automatically provide extra light when it is needed. Completely automated flash units, in fact, have already been developed and are in wide use as accessories *(pages 42-43)* and it only remains to put them inside the camera.

Perhaps even more welcome than fully automatic control of shutter and aperture will be a camera that focuses itself. Automatic focusing systems already exist *(pages 40-41)*. Their refinement and adaptation to practical, everyday use may be some distance away, though, because focusing involves several complex functions. First, a measuring device must determine the distance between the camera and the subject. Then an electronic computer has to calculate how much the lens must be adjusted to bring the subject into focus. Finally the lens, or elements in the lens, must be physically moved to achieve the necessary adjustment. Camera designers have the know-how and the hardware to do the first two operations compactly and efficiently. But a serious problem occurs in moving the lens. This task is simple, but it cannot be done with transistors; it requires an electric motor, which requires powerful batteries, adding size and weight that cancel the main advantages—lightness and compactness—of miniature cameras.

A major breakthrough in the development of a strong and long-lasting but compact power source is bound to come. When it does it will bring a full-scale revolution to photography. Today's automated cameras, it should be observed, are only *controlled* by electronics: the work is done by very low-powered motors or magnets that, at best, actuate a lever or two to govern the shutter or aperture. The actual operation of the camera—winding the film, moving the shutter, adjusting the aperture, focusing the lens—is done by the photographer's muscle power and an intricate array of springs, gears and regulating devices. When a potent power source becomes available these mechanisms will disappear and the camera will be operated, as well as controlled, entirely electronically. The eventual power source may well be a nonradioactive atomic battery; this is already being developed. It is entirely conceivable that, some decades hence, cameras will come from the manufacturer with built-in power supplies that will last for years.

Electronic controls have few moving parts, so they are easier to assemble than complicated mechanical shutters and apertures. Some can, in effect, be stamped out as single, complete units. Manufacturing economy is one reason it will be possible to automate inexpensive cameras, and more elab-

orate cameras will eventually reap the same pecuniary benefits. More important, electronic controls are more accurate than springs and gears, they are less likely to get out of order and they make virtually no noise. Finally, electronic circuits and controls can be designed to fit into exceedingly small spaces—witness the shirt-pocket transistor radio. The fully electronic camera of sometime in the not-too-distant future, therefore, can be much more compact than most cameras of today.

For the sophisticated photographer the pertinent question about automation is not how much is possible or economic but how much is desirable. The idea of a camera that does all the thinking, turning out "satisfactory" exposures, all precisely focused and as alike as peas in a pod, does not appeal to him. There are times when he wants to overexpose to saturate colors, or to underexpose to allow for a contrasty subject, or to use a slow shutter speed to blur motion or a very large aperture to soften a background. A computer, which only takes a consensus of various conditions, is not capable of making these kinds of decisions for him.

The designers of more elaborate automated cameras have recognized this problem and have made it possible for the photographer to switch off the electronic circuits and set the shutter or aperture manually when he desires. Nevertheless, in many situations the serious photographer will be glad to let electronic controls do the setting-up chores so he can concentrate on the most important part of his job, that of composing the picture. His camera of the future unquestionably will be as fully automated as any made for snapshots, but with some refinements. He will be able to switch on the electronic shutter and the electronic aperture either separately or together. And he will maintain the added option of shutting them both off, and doing the computing himself, when he pleases.

While the fully automated camera is only now emerging, the electronics revolution began to affect lensmaking decades ago, soon after giant research and industrial computers had come into general use. Those computers were seized upon by optical scientists because they can carry out lengthy, complex calculations so rapidly—and tedious computation is the principal chore in lens design. Computers have cut the job of creating a new lens, or improving an old one, to minutes instead of the weeks or even months that manual calculations used to take. As a result, an increasingly broad range of lenses have become available for dozens of different cameras, including many special-purpose lenses: extreme wide-angles, large-aperture telephotos, mirrors, zooms and others. Without the help of electronics many of these lenses would have been impractical to make, simply in terms of the time and expense required for their computation—and some would have been totally impossible to design.

For some time to come, optical designers will be busy consolidating the considerable gains they have already made. Their principal aims will be to make lenses still more precise, smaller and lighter, and—in response to the popularity of zoom and macro close-up lenses—more flexible.

Further in the future, the most significant goal will be to reduce the number of elements in lenses—some present ones have as many as 16 different pieces of heavy glass. Multiple elements are needed in all lenses today because a single element can cause either an overall convergence or an overall divergence of light rays that pass through it, but not both. But both actions—and thus both types of elements—must be used to keep the light rays on an even course, to correct distortions and to bring them into focus on the film. Scientists are working on ways to arrange the internal structure of a single piece of glass (or other material) so that some parts of it will cause light to converge while other parts of the same glass will cause it to diverge. When this is accomplished, virtually every camera lens can consist of but a single element. The only exceptions will be zoom lenses, and even the most complicated of these will need only two or three elements.

Yes, Nicéphore Niépce would be amazed to see the latest cameras and those that are about to appear. But after a bit of reflection he might observe that the fundamental system of photography is just like the one he employed to take the first dim and fuzzy picture of his French farmyard. And he would be right. For all their computerization and automation, cameras are still essentially light-tight boxes with a few basic parts—shutter, lens, aperture and a viewing-focusing device. They perform the same function they always did—that of concentrating light and controlling the amount of it that hits a sensitized silver emulsion—the film—inside the box. Any fundamental change in the system will depend primarily on the invention of an entirely new kind of sensitized material. Such a development may very well come sometime in the future (Chapter 3). If and when it does, the designers of cameras and lenses will do their share in bringing off still another revolution. There is a saying among inventors that the man who says something cannot be done is likely to be interrupted by the man who has just done it. □

A Choice of Methods for Automatic Exposure

Camera designers naturally want to know which basic system of exposure control most photographers want on cameras of the future. Will they prefer to have an automatic shutter and adjust the aperture themselves? Or will they want just the opposite—an automatic aperture and a handset shutter? Business fortunes are at stake.

But the options are important to the photographer, too, because the kind of exposure control he has influences the kind and quality of picture he gets. Some of the effects are very subtle —producing more or less graininess, stronger or weaker colors—but at the very simplest level the shutter speed determines the look of movement or lack of it in a photograph, while the aperture determines its depth of field. The photographer who is mainly interested in sports or wild animals will want to set the shutter speed himself to stop the movement of his subjects, and he may be glad to let the aperture take care of itself. But if he shoots portraits or landscapes he is probably more interested in keeping control of the depth of field; he will want to set the aperture and let the shutter set itself.

Both kinds of automatic exposure systems are being made, so the photographer can choose the system he prefers. Which will become dominant remains to be seen but it may be neither, for a few attempts are being made to combine some features of both in one mechanism.

With an automatic aperture system, the photographer, after having set the shutter speed, focuses on the subject with the lens wide open. What happens next varies from camera to camera, but in one, release of the shutter button ac-tivates a built-in exposure meter. It gauges the amount of light reflected from the subject and passes this information to an electronic computer. The computer calculates how much light is needed, in combination with the preset shutter speed, to give a correct exposure. This information is next passed to another circuit, which starts and stops a thimble-sized battery-powered motor. The motor itself does not move the overlapping diaphragm leaves that provide the adjustable lens opening, but determines how far the leaves can close—in effect setting the f-stop. The actual movement of the aperture blades is accomplished in the regular way with a spring mechanism. The whole operation takes only a split second.

With some cameras the photographer can find out, before taking his picture, what f-stop the computer has chosen. Pressing the shutter button part way actuates a needle that points to an f-stop scale inside the viewfinder. If he wants more (or less) depth of field than the computerized aperture setting allows, he can readjust the shutter speed and the computer will automatically adjust the f-stop. With more expensive cameras he can also switch off the computer entirely, bypassing the system, and set both aperture and shutter speed by hand.

The automatic shutter system has an advantage over manual as well as other automatic exposure controls: It makes possible an infinite number of settings throughout its speed range. If the computer calls for 1/357 second, that is precisely what the film gets.

With this kind of camera (one is illustrated at right), the photographer, after setting the f-stop, presses the shutter button to activate a built-in exposure meter. As in the automatic aperture system, the meter gauges the amount of light reflected from the subject and passes this information to a computer. The computer calculates the shutter speed that will be needed, in combination with the preset f-stop, to produce a correct exposure. This information is next passed to another electronic circuit that actuates a battery-powered electromagnet. The magnet moves a lever that determines how fast the shutter will open and close. The shutter itself, again, operates in the usual way, powered by a spring mechanism that is tensioned when the film is advanced. Some cameras also have a mechanism that sets the aperture to a preselected f-stop when the shutter is released.

On the model shown here, an extra computer step is needed; the exposure meter makes its reading through the SLR's lens, and a "memory circuit" must hold the reading for the instant it takes the SLR mirror to swing out of the way before an exposure, and only then pass the reading on to the electromagnet. On cameras whose exposure meters are separate from their lenses, no delay is required.

If the light available is not enough (or too much) for the shutter-aperture combination that has been chosen, a "reject" signal warns the photographer when he presses the shutter button part of the way down. He must then reset the aperture to obtain a workable shutter speed. Some cameras signal with a needle visible in the viewfinder, or with a flashing light, while others simply refuse to work. On some cameras with automatic shutters all controls can be set manually, if necessary.

From the outside, a camera with an electronically controlled automatic shutter (above) looks almost exactly like its nonelectronic counterpart—and for that matter much like regular SLR cameras made by other manufacturers. But a cross section of the same camera—sliced away with a diamond-bladed saw—reveals an ingenious array of electronic innards (right). The disk to the left of the lens in the picture above covers a socket that holds a six-volt battery to power the electronic controls. Directly above the socket is an electromagnet that is connected to the shutter-speed mechanism, setting it in accordance with light conditions gauged by a meter behind the lens. In the base of the camera (right, below) are other electronic components that comprise, in effect, a miniature computer. The way the system works is described in the text at the left.

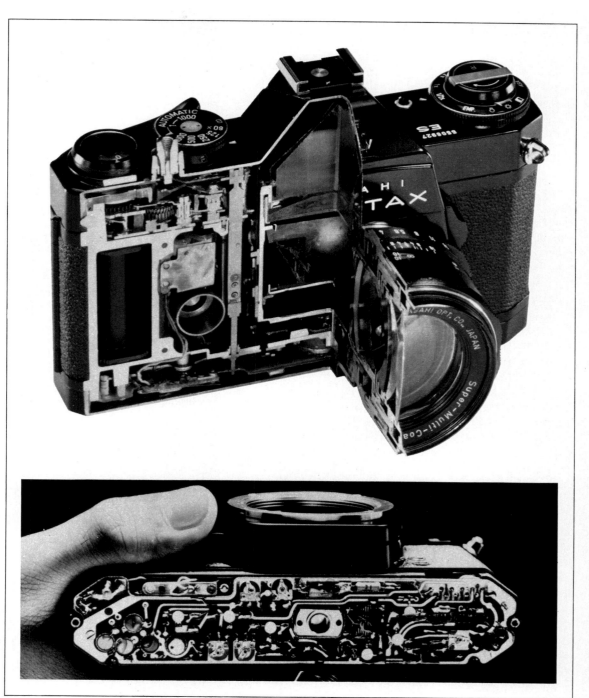

Two Approaches to Automatic Focusing

Two distinct approaches are being followed for automatic focusing systems. They differ fundamentally in the way each arrives at correct focus. The system shown on this page uses a "passive" device and sets focus by gauging the amount of contrast that is present in an image; the other, on the opposite page, employs an "active" device to measure the actual distance between the camera and the subject.

The passive system relies on light reflected from the subject. Part of the image formed by the lens is scanned by a system of light-sensitive cells. As the image changes from dark to light, outputs of the cells change accordingly. The rate at which this change occurs indicates the contrast in the image —the outputs vary slowly where there is a gradual change of tone, and rapidly where there is abrupt tonal variation. All this information is relayed to a computer, which actuates a motor to adjust the lens until the image displays maximum contrast. The point of maximum contrast is also the point of sharpest focus, since a blurred image changes gradually from dark to light and only a sharp image will show an abrupt demarcation between tones.

In the present state of development of the passive system, it can focus accurately only on a subject that has a good deal of contrast. As one expert has observed, it works better on zebras than on horses. But if light-measuring devices can be refined—as they have been in automatic exposure systems —and if the system can be made more compact than the unwieldy apparatus shown here, a passive focusing system may very well become a practicality for small-format cameras.

The 80mm automatic focusing lens above works by gauging the contrast in parts of the images. It consists of a mirror optical system around which are grouped the controls, batteries and the electric motor that adjusts the lens. The entire unit has 15 optical elements, is nearly a foot long and weighs six pounds—about three times as much as the camera, but only a quarter as much as the assembly pictured on the opposite page.

The experimental 16mm movie camera above focuses automatically, gauging distance by bouncing infrared light rays off the subject. The components are inside the box below the lens. The battery pack, which the photographer carries in a separate unit, usually on his hip, weighs nine pounds; the camera itself weighs 23.7 pounds.

An active automatic focusing system differs from the passive system described on the opposite page in actually sending out signals to measure the distance between the camera lens and the subject. In theory at least, the signals may consist of any form of radiant energy that will bounce back—such as light, sound or radio waves—but the movie camera shown here uses infrared light rays. This kind of radiation is an especially good choice because infrared light does not register on ordinary photographic film.

The focusing mechanism gauges distance by measuring the angle between rays reflected from the subject—the same basic principle used in rangefinder focusing cameras. Rays bouncing off one point on the subject are picked up by a mirror system and sent to two separate light-sensitive cells. When these cells sense equal amounts of light, a computer circuit "knows" that the mirrors are properly angled at the subject point—the narrower the angle the greater the distance. The computer then actuates an electric motor to adjust the lens accordingly.

While this system, in its present state of development, is very complex and bulky, it has an inherent advantage over the passive system: it measures distance rather than image contrast, and automated instruments are more precise at measuring the former than the latter. For this reason many technologists consider a miniaturized version of an active focusing system to be the best bet for the future.

Flash Units That Adjust Themselves

The trouble with using flash—whether the flash powder of the old days or modern bulbs or electronic units—has always been the difficulty of calculating the amount of light required. By the time the photographer was ready to take a shot of Junior saying his prayers, Junior was probably already asleep. Now automatic flash units can do all the calculating—and do it instantly and accurately. Units of various sizes now automatically vary the amounts of light they emit to give perfect exposures of almost any subject, whether babies or football fields.

Although they do contain some advanced electronic components, automatic flash units operate on a simple plan. A sensing device similar to those in exposure meters measures the light reflected from a subject before the picture is made (and thus before the flash fires). A computer then calculates how much additional illumination is needed for a proper exposure. When the shutter is released, the computer controls the duration of the flash, determining how much light is produced.

To use an automatic flash the photographer needs only to adjust for the speed of the film he is using, by setting a dial on the unit. The dial then tells what f-stop to use with that film, and the camera aperture is set accordingly. Unless the film is changed, the f-stop need not be changed. The shutter is set at the proper speed for flash synchronization and is of course left at that speed. Thus, with the flash connected to the camera and with the automatic circuit switched on, all the photographer has to do is focus and trip the shutter.

The automated controls of the units currently available leave little to be desired in ease of operation, and the best of them are quite accurate. It is a good idea, however, to make a series of test exposures with any new unit because the actual light output sometimes varies a bit from the amount claimed by the manufacturer. But this variation, if any, is consistent—always a bit more or a bit less than the rated output—so the photographer needs only to readjust the film-speed dial on the unit or the f-stop on the camera to achieve consistently accurate results.

Future flash units will have longer-lasting power supplies—and eventually permanent ones—to replace the rechargeable or throwaway batteries now used. When such power improvements are available, small units like the one at right will become smaller still and will be built right into the camera. Larger units like the one at the far right will be no bigger than the miniature models of today and will have a self-contained power supply providing more illumination than big battery packs do now.

Small automatic flash units like the one above are mounted on the accessory shoe of the camera. This one, which is typical of those in its class, is about the size of a pack of cigarettes and weighs 7½ ounces. It has a built-in battery that permits 45 flashes and then can be recharged in about 14 hours. It can also be operated on household current. The recycling time between flashes is 8 to 10 seconds. The flash duration ranges from 1/1700 to 1/40,000 second, and the flash will illuminate subjects anywhere from 2 to 12 feet away.

A larger automatic flash unit is mounted on a bracket that is attached to the camera. Power is supplied by batteries in a separate shoulder pack (right), which accounts for most of the rig's total weight of 4¾ pounds. The batteries permit 200 flashes, after which they can be recharged in 16 hours. They can also be replaced at any time with fresh batteries, a desirable option on extended shooting assignments. The flash duration ranges from 1/250 to 1/40,000 second. The total light output is about twice that of the unit at left.

Designing Lenses Electronically

Lenses are among man's most ingenious creations, but they also can be among the most difficult. Making them is easier today than it ever was, thanks to the advent of electronic computers. But it is still so difficult that nobody is about to produce a perfect one.

This failure may seem surprising, since a lens is fundamentally a rather simple device. Whether it is a single disk of glass like those used in basic box cameras, a special-purpose camera lens with many glass elements *(right)*, or a gigantic mirror lens set in an astronomical telescope, it does the same thing: collect light rays reflected from a subject and bend them so they come together to form an image.

In most camera lenses the bending action depends chiefly on the composition of the glass, the shape and size of the glass elements, and the placement of the elements. Now if all these factors could be fitted into one overall theory, the paths of all light rays passing through the lens could be precisely predicted on the basis of optical and mathematical laws. The designer could work out a few equations to compute the sizes, shapes and composition of whatever elements he needed.

The trouble is that no such generally applicable equations exist in usable form, and the action of a lens cannot be calculated as a unit. Instead a trial-and-error method must be followed. The desired performance of the lens is assumed. Then the paths of a number of light rays going through each element must be calculated individually to see how well the assumptions work. The assumptions have to be adjusted and the rays retraced over and over again before a successful design is arrived at. Repeated attempts are necessary because each change, instituted to correct one fault, usually introduces new faults, so every lens is a compromise.

Doing this ray tracing manually is an exceedingly tedious process. Even with fast desk calculators, it used to take many months to work out the specifications for a routine (though complex) system such as a 50mm f/2 lens.

Now, however, electronic computers have revolutionized the task of designing lenses. Today they can do all the necessary calculations a billion times faster than desk calculators could do, cranking out the figures for a complex lens design in a few minutes. In so doing, moreover, the computer can trace the paths of hundreds of separate light rays—instead of the handful that could be traced with a desk calculator—and thus predict more accurately how a lens will work even before it is made.

Computers are also taking an important role in actually manufacturing lens elements. They help to formulate the chemical structure of the glass. They govern automatic machines that grind and polish the glass blanks, and then check the curvature and thickness of the finished elements. They can do all these operations with much greater speed and accuracy, and therefore at relatively less cost, than humans.

Thanks to such automation these manufacturing steps turn out lenses that are nearly as good as anyone could hope. The best grinding and polishing jobs today are 95 per cent accurate. The finest optical glass is 99 per cent perfect. And another important step in lensmaking, that of coating the glass surfaces to reduce reflections, is about 95 per cent successful. These close approaches to perfection are impressive strides toward banishing most of the aberrations that stand in the way of making a perfect lens.

Yet the lensmakers are still not satisfied. They hope to come closer still to the ideal by programing computers to do more than the routine calculations. Already some computers are being set up to evaluate the results of their calculations as they go along, to figure out how to get around the aberrations that crop up. Eventually a computer might be programed with a complete work plan and ordered to continue flicking its transistors on and off until it arrived at exactly the lens that was needed.

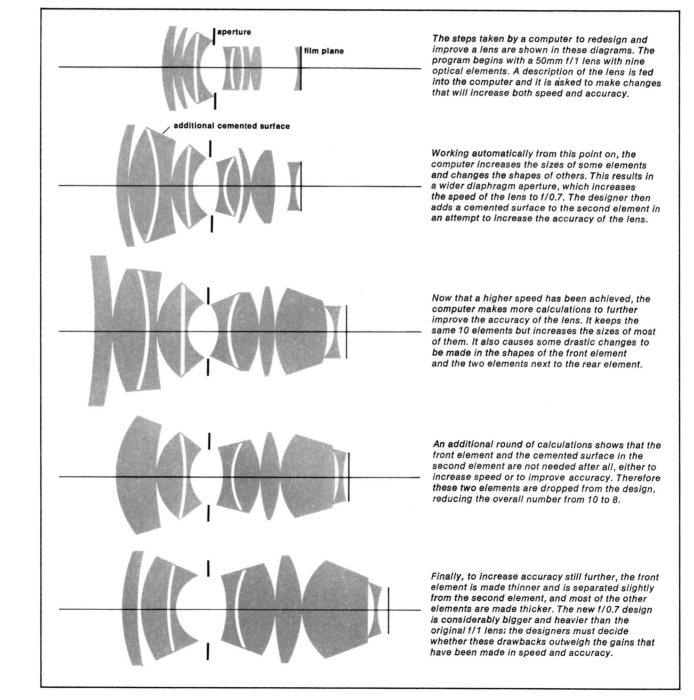

aperture

film plane

The steps taken by a computer to redesign and improve a lens are shown in these diagrams. The program begins with a 50mm f/1 lens with nine optical elements. A description of the lens is fed into the computer and it is asked to make changes that will increase both speed and accuracy.

additional cemented surface

Working automatically from this point on, the computer increases the sizes of some elements and changes the shapes of others. This results in a wider diaphragm aperture, which increases the speed of the lens to f/0.7. The designer then adds a cemented surface to the second element in an attempt to increase the accuracy of the lens.

Now that a higher speed has been achieved, the computer makes more calculations to further improve the accuracy of the lens. It keeps the same 10 elements but increases the sizes of most of them. It also causes some drastic changes to be made in the shapes of the front element and the two elements next to the rear element.

An additional round of calculations shows that the front element and the cemented surface in the second element are not needed after all, either to increase speed or to improve accuracy. Therefore these two elements are dropped from the design, reducing the overall number from 10 to 8.

Finally, to increase accuracy still further, the front element is made thinner and is separated slightly from the second element, and most of the other elements are made thicker. The new f/0.7 design is considerably bigger and heavier than the original f/1 lens; the designers must decide whether these drawbacks outweigh the gains that have been made in speed and accuracy.

A Big Lens Cut Down to Size—with Mirrors

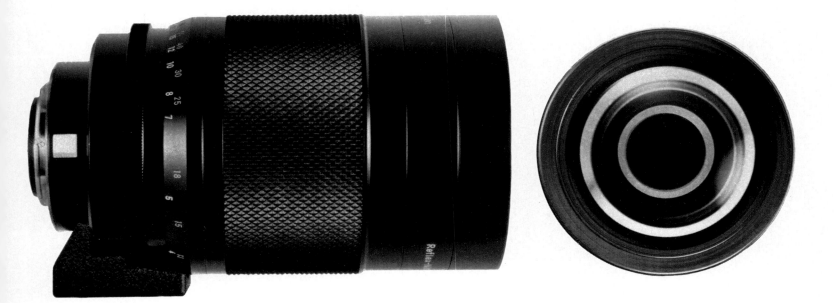

Theoretically there is no limit to the size of a telephoto lens. But beyond a certain point—about 400mm or 500mm —regular telephotos become so heavy and unwieldy that the mobile photographer cannot or will not carry them around. Small lenses with comparable power can be produced, however, with the help of mirrors.

In a mirror lens such as the one shown here, light rays are reflected back and forth inside a tube only about 5½ inches long before being conducted into the camera. The total distance the rays travel in their bouncing journey is the same as if they had gone directly through the much longer tube of a regular lens. Thus the focal length of the mirror lens above is identical to that of a 500mm regular lens. Yet it is only about half as long and half as heavy.

Mirror lenses do have some drawbacks. If a scene has a shiny background, uncontrolled reflections occur in the mirrors of the lens and these reflections—actually images of the optical system itself—appear in the picture as out-of-focus spots or as doughnut-shaped globules of light. Sometimes these aberrations can produce strikingly artistic effects *(far right)*, but they are aberrations nevertheless.

Another problem is that a mirror lens has no diaphragm—it would obstruct the mirror system—so there is no way to control exposure with the lens and no way to vary depth of field. The exposure is determined solely by the shutter speed or by inserting a neutral density filter in the rear of the lens.

In spite of these deficiencies, mirror lenses serve present needs for light, compact telephoto systems. For the future they present challenges to optical designers to produce lenses with more versatility and even greater portability.

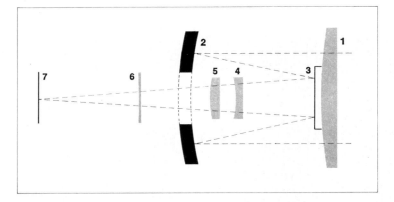

Side and head-on views of a 500mm mirror lens, and its optical system, are shown above. In the diagram, light enters a corrective lens (1), hits a primary mirror (2) and is reflected back into a secondary mirror (3). From here it bounces through other corrective optical elements (4, 5), passes through a hole in the primary mirror and a filter (6) and finally reaches the film (7).

Some Africans gathering firewood (right) were ▶ photographed with a mirror lens like that above. Reflections from water create tiny images of the lens itself. Such an aberration would mar some pictures, but here it adds a beauty of its own.

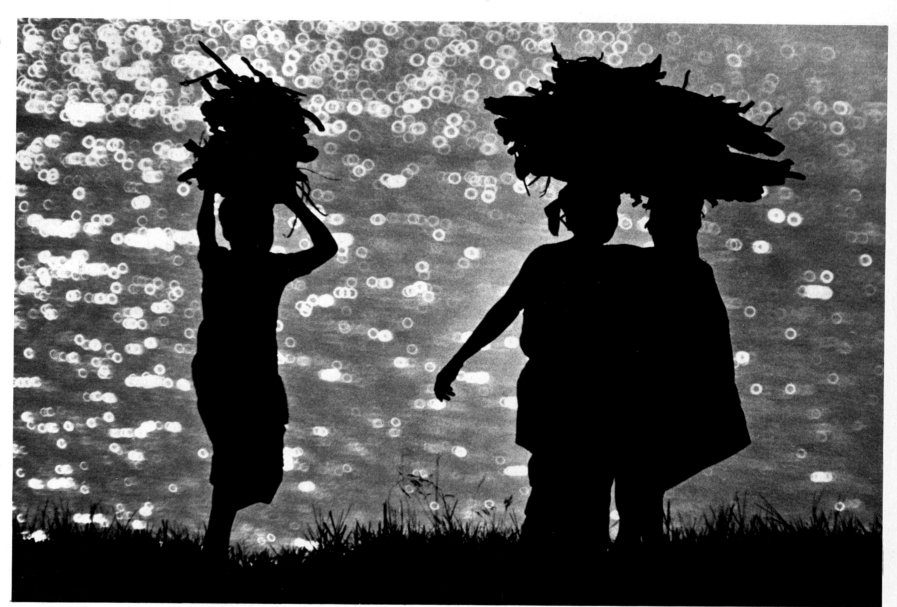

MARC AND EVELYNE BERNHEIM: *Ivory Coast Villagers*, 1971

47

A Lens That Makes a Crooked Image Go Straight

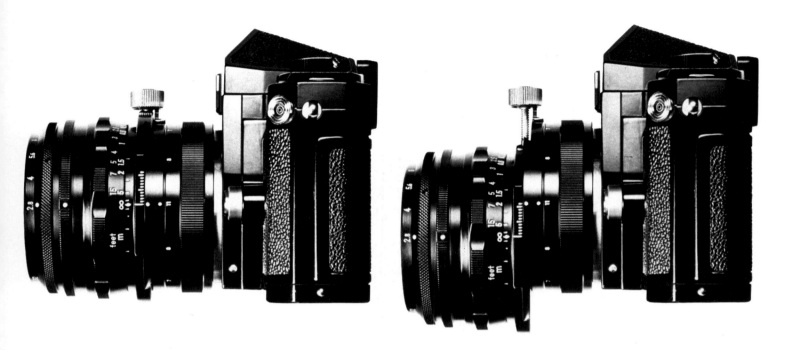

Despite its tremendous versatility, the miniature camera has never been very popular for taking close-ups of tall buildings or full-length portraits of basketball players. The trouble is with the lens: it is rigidly mounted on the camera, and when it is tilted up or down, the film—and therefore the image—is tilted in turn. This distortion is particularly acute with wide-angle lenses because they emphasize objects in the foreground at the expense of those more distant. When a wide-angle lens is tilted upward, the subject thus appears to converge from bottom to top—as the columns do in the topmost picture on the facing page—as if stretched on a sheet of rubber.

The lens shown here is designed to take care of that problem. It is a 35mm wide-angle lens that can be moved up, down or sideways so that the view will include the top, bottom or edges of a large subject. At the same time optical elements in the lens can be shifted so that light rays from the subject are bent and redirected into the camera, which remains level. The image then looks upright and natural.

The idea for this new device, called a perspective-control lens, is taken from large view cameras. These cameras still offer a good deal more flexibility than the smaller SLRs because their lenses not only can be moved to various positions but can be swung or tilted to any angle; on elaborate models even the backs are adjustable. But the obvious long-range aim of designers is to combine the portability of the miniature camera with the distortion correction of the big view camera. The perspective-control lens represents an important step toward that goal.

A 35mm perspective-control lens is mounted on an SLR camera in the usual way (above left) and looks much like a moderate-power telephoto lens except for a knurled screw on the mounting ring. When this screw is turned the lens slides up or down, and optical elements in the lens shift as much as 11 millimeters off center (above right). This changes the perspective so that tilting objects are straightened out. Shifting the optical system also changes the overall view, but the original view can be maintained by rotating the entire lens (including the shifting screw) to any of 12 different positions in a full circle.

When a perspective-control lens is used in its basic (or normal) position, the aperture, seen from the rear, is dead center (below) and the effect is that of an ordinary wide-angle lens. But like all wide-angle lenses, this one produces a keystone effect when tilted upward (right). Thus the statue of George Washington seems to lean backward and the columns of the old Sub-Treasury building on New York's Wall Street appear to converge as they rise toward the top of the picture.

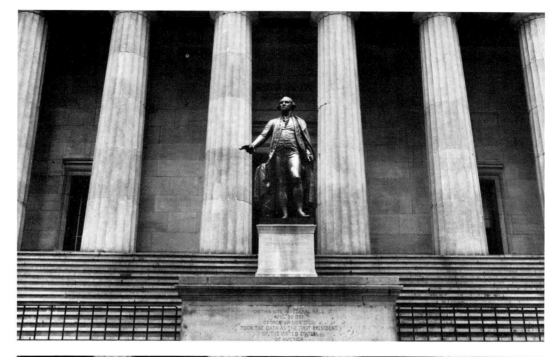

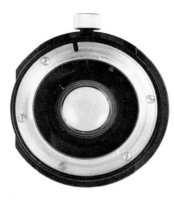

To correct the perspective the optical system is shifted so that the aperture now appears to be at the top of the lens (below). The lens also has been rotated 180°. Because the perspective has changed, the tops of the columns are lost, but the columns—and the statue—now stand straight. Without the corrective lens the camera would have had to be raised many feet, on a ladder or a high platform, in order to achieve this effect.

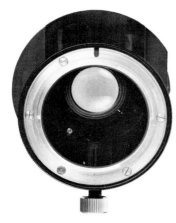

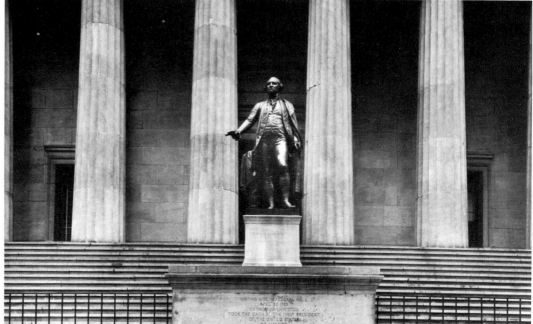

Color from Black and White

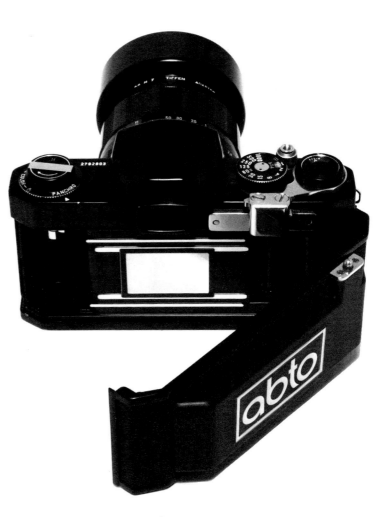

Good ideas in photography have a way of popping up repeatedly until someone makes them work. For more than a hundred years experimenters have been trying to record color subjects as black-and-white images and then to get the color back again by projecting the images through color filters. Some of the methods worked but were cumbersome. Now a new version of a previously tried principle seems practical.

The technique depends on making three separate black-and-white images of the subject, one for each of the three primary colors. When the images are projected through primary-color filters and are recombined, the colors of the original subject reappear—nonprimary shades being generated from mixtures of primaries. Present-day color films introduce colors by dyeing, but the new process, called Abtography, adds color to the light that projects the separate images. Color prints can be produced from the film by standard processes that are now in use.

In this system, the camera has a sheet of glass crosshatched with a grid of transparent lines of red, blue and green—the primaries. This grid divides the lens image into red, blue and green parts, creating three grid images on ordinary black-and-white film (diagram opposite). One of these grids is made by light going through the red lines on the glass and represents the red parts of the original subject. The others correspond to the blue and green lines on the glass and represent the blue and green parts of the subject.

To reintroduce color, the three coded grid images are separated so they can go through appropriate color filters. The separation is caused by the fine lines of the crosshatched grids, which act as a "diffraction grating." Such a grating has a peculiar property. When light rays pass through it, they interact to produce a series of images that are spread out at right angles to the lines of the grating.

In this case there are three gratings superimposed over one another. The lines in each coded image, representing the primary colors, are crisscrossed in different directions. Thus light rays are spread in three directions to form three distinct sets of images when the rays hit the grating. Some rays are bent in one direction for red, others in a second direction for blue and still others in a third direction for green. The images that represent red are thus directed toward red filters, while the images representing blue and green are directed toward filters of their respective colors. Some light also goes straight through, unfiltered; it is not colored but adds richness to the final image. All of the light rays are then focused by the front projector lens to form an overlapping, full-color image.

This system has proved workable for making color television programs on black-and-white movie film. However, when it is used for still pictures, which are often projected at 30 or more times original size (compared to an enlargement of only 11 times on a typical TV screen), the color grid shows up. But finer resolution can be obtained by using more finely lined filter gratings, and the future is likely to bring a perfected system for large-scale projection of color transparencies made from economical black-and-white film. When that happens, it will be another case of a long-tried idea whose time has come.

A small rectangular glass plate that permits color pictures to be encoded on black-and-white film fits into a niche in the film plane of the otherwise standard 35mm SLR camera above. Although the plate appears to be white and opaque, it is actually a transparent filter inscribed with a fine grid of colored lines. Eventually the plate will be removable. The photographer then will be able to switch, with the same camera, from color-coded pictures to regular black and white or color.

picture-taking sequence

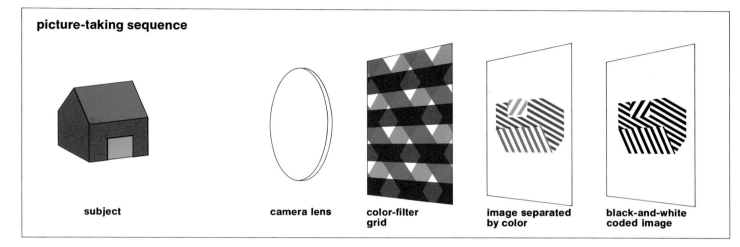

subject camera lens color-filter grid image separated by color black-and-white coded image

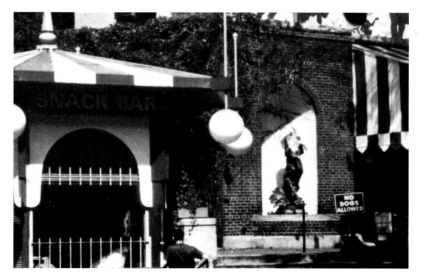

The process for recording color images on black-and-white film is shown above. In the diagram, light from the subject—a barn of primary colors—passes through the lens and a color-filter grid. Since the red, blue and green rays can pass through only the filter lines of their own color, they emerge from the filters as three separate "coded" images, representing colors in the original subject. The images are recorded in black and white on regular black-and-white film. The picture, when printed (above, left), looks like any other, but a magnification (above) reveals the grid. Color retrieval is shown on the next page.

color-projection sequence

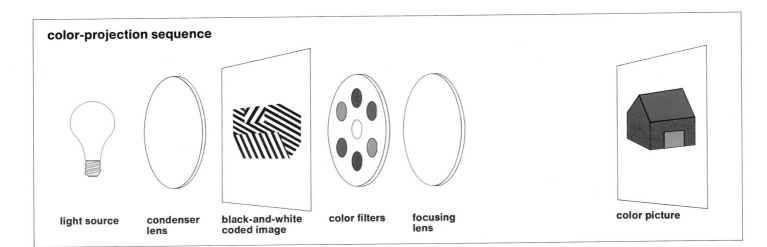

light source | condenser lens | black-and-white coded image | color filters | focusing lens | color picture

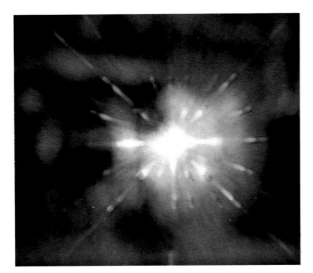

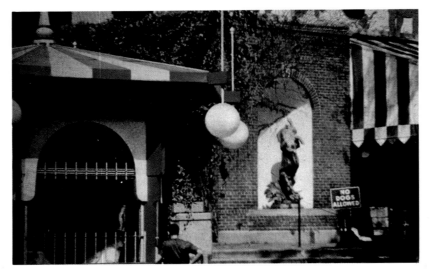

To regain the color that is coded on the black-and-white film (diagram at top), light is diffracted, or spread, by the grid image so that different rays emerge in different directions and are sent through color filters. These are positioned so that the rays diffracted from red-coded portions go through red filters, green through green, etc. The filters color the "red" image red and screen out spurious colors—side effects visible in the unfiltered view above. All the filtered rays are then brought into focus by the front lens of the projector, giving a full-color picture (above right).

GEORGE E. OBREMSKI: *First Impression—A Xeroxed Portrait,* 1970

"Films" of Tomorrow

The wafer-thin slice of coated ceramic material looks like a simple piece of clear yellowish glass. Yet when it is charged with electricity and exposed to light shining through a photographic negative, an image forms inside it. When the electricity is turned off, the picture will remain indefinitely. If placed in a slide projector, the picture can be flashed on a screen as though it were on a 35mm transparency. To remove the image, all it takes is another charge of electricity and a flash of light. Not a trace of the picture remains, and the ceramic is ready to transcribe another picture.

Called Cerampic, this unconventional method of picture reproduction is a promising means of printing photographs, diagrams or documents. It is particularly useful for reconstructing pictures that have been broken down into electrical impulses so that they can be transmitted by radio beams or over telephone cables.

Cerampic has survived its first tests at Sandia Laboratories in New Mexico. Whether it will ever become a "film" for convenient use in ordinary cameras remains to be seen. It is so far merely one of many new ways of making, processing or relaying pictures that scientists are pursuing. Their work reaches across the entire spectrum of photographic activity, from refinements of the Polaroid instant-picture system to new office copying machines, and from new ways of dry-processing pictures to elaborate and expensive machines that can turn a black-and-white original into a print in colors—whatever colors are selected by the operator. Most of these processes are, like Cerampic, only in the theoretical or experimental stage, and some will never advance beyond that. Most are presently so costly or complicated that for some time their practical use, if any, will be restricted to large film companies and laboratories. Yet out of all this expensive, theoretical, seemingly impractical work will almost certainly come the prototypes for the next generation of photographic technology.

The majority of the new image-recording processes are being pursued in the hope that one will dethrone scarce and costly silver as the essential ingredient in photography, a position it has held since the invention of the daguerreotype. But silver's remarkable capacity for creating smoothly toned images is hard to approach, let alone better. And efforts continue to improve the silver system still further. One long-desired step is an easier, faster way to extract prints from exposed film without requiring the use of liquid processing chemicals. Polaroid's pod of jellylike developing and printing substances is fast enough for anybody, but it is not moisture free—and dry printing is one of the desired ends to lessen or eliminate the messy liquid chemicals that photographers must deal with when working in a darkroom.

One proposed method of dry processing is based on using printing-out

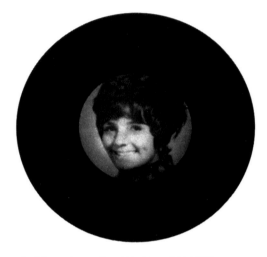

A picture of a pretty girl is formed in a thin, transparent slice of ceramic, a new imaging material known as Cerampic. The circular frame, shown actual size, protects the ceramic and contains the wiring needed to convey the electrical charge that is used to print the picture in the material. The process involves no silver emulsion and requires no chemical treatment.

paper—the type that studio photographers employ to make quick proofs of portraits so that the customer can decide what pictures he will buy. Printing-out paper is light sensitive like ordinary printing paper but it does not require any processing and it produces a visible image after a rather lengthy exposure to bright light. The pictures tend to fade, however, and even at their most distinct they have a reddish purple cast. This is fine for proofs, but disastrous for even a casual snapshot.

A printing-out paper that could provide immediate, permanent black-and-white prints from negatives does not exist as yet. But one new type can be made fade-resistant by heat. After this special Kodak paper is briefly exposed to a negative, heat of 450°F.—near the paper's scorching point—is applied. The heat makes the emulsion less sensitive to light, preventing the unexposed areas from darkening with additional exposure. Next the paper is flashed with high-intensity light, which darkens the exposed areas, without affecting the unexposed areas stabilized by the heat. Continued exposure develops the image into a picture with dark areas of deep blue and an extensive range of tones that get a rich look from the creamy color of the paper base. Because of the high heat this special paper requires, it probably will be put to initial use in commercial processes such as photographic typesetting for printing books and magazines. But the principles behind it may lead before long to dry printing in the darkroom.

The continuing effort to find new and more convenient silver systems is understandable because the reaction of light with silver-containing molecules is such a delicate (though readily controllable) process. When crystals of silver compounds are struck by light, electrons in the crystals absorb some of the light's energy and move toward the surfaces of the crystals. There they combine with the crystals' silver components to form atoms of silver. The spots where they combine are called development centers and constitute the picture's latent image, so faint it cannot be seen even with a microscope. The developing chemicals use these minute concentrations of silver as the starting point for converting the crystals entirely to silver, making the image visible on the film. When the negative is projected onto printing paper, the silver in the paper's emulsion catches and holds the image.

Excellent though this image may be, its future is clouded, for the world is bound to run out of silver. It is produced mainly as a byproduct of copper, lead and zinc mining, and nobody knows how much of it is still unmined, though the United States Bureau of Mines estimates the American reserves at 1.3 billion ounces. World production is about 250 million ounces a year; about half of that is consumed in the United States; and about one ounce out of every three used in the United States is consumed in photography. To con-

serve silver supplies, the major United States manufacturers of film and printing paper, as well as the large processing laboratories, have undertaken a massive reclamation effort by salvaging the silver particles that remain in developing tanks and on printing paper. These efforts have had great success: nearly half of all the silver manufacturers use, or about 17.5 million ounces a year, is now reclaimed. As the practice of reclaiming grows—perhaps extending to the home darkroom—this figure will continue to rise. Of all the silver used in photography, however, only two thirds is ultimately recoverable—the other third is used up in the process of picturemaking.

While many of the alternative photographic processes, such as Polaroid or Kodak dry processing, depend on silver, others require little or no silver at all. Polaroid itself may have discovered a way to reduce the amount of silver needed to produce pictures, and at the same time gain an increase in film speed. In the course of routine testing of some Polaroid film, laboratory workers noticed that, with very low exposure, the film produced a print with an extremely faint negative image instead of the positive image obtained when the film is normally exposed. The researchers realized that if this faint print could be made to have high contrast, it might be used to make satisfactory positives, even though the original film negative was hopelessly weak. Scientists at Polaroid discovered that adding a chemical called 1-phenyl-5-mercapto tetrazole (PMT for short) to the developing gel of the film helped produce negative prints of high quality, with a good range of gray tones, at film speeds as high as ASA 20,000. Usually the high speed of Polaroid films results from strong concentrations of silver in the emulsion, but the PMT-bolstered images can come from emulsions with as little as a thirtieth the normal amount of silver. This may lead to an astounding reduction in the silver required for Polaroid film. Experimentation with PMT and the reversed prints is continuing.

Another promising breakthrough in the search for silver-saving methods was made in 1968 by Edith Weyde. In her laboratory in the Agfa factory at Leverkusen-Bayerwerk, Germany, she determined that a weak image delivered by a low-silver film could be strengthened by a tiny application of the common chemical hydrogen peroxide. After the low-silver film is processed, it is exposed to peroxide vapor and then heated. Tiny oxygen bubbles immediately form in the film emulsion and increase the density and contrast of the image. So little silver material is used in the process that the developed film does not need fixing and washing. Moreover, film treated in this way gains speed, its ASA rating increasing by about 10 times. Thus the low-silver film has a higher speed and is easier to process.

Metal oxides also can be employed to lessen the amount of silver required to produce an image on paper or film. In the Itek-RS document-copying pro-

cess, an oxide of a metal such as zinc or titanium is the light-sensitive agent. When exposed to light it produces an electrical latent image. The paper is then placed in a solution of silver nitrate. The silver particles are attracted to the exposed areas of the film by the electric charges generated when the light hits the metal oxide. In development, the silver adhering to these areas forms the image. Since the silver goes only where the image is and none is washed away in processing, much less of it is needed than in normal photographic processing. Developing does not remove the light-sensitive material (the oxide), as it does with conventional silver film, so that an oxide printing paper or film can be re-exposed to add new visual information even after it has been processed.

An intriguing low-silver system that produces positive images without the necessity for negatives has been propounded by J. Malinowski, a professor at the Institute of Physical Chemistry in Sofia, Bulgaria. Malinowski has devised an emulsion that uses a lead compound instead of a silver one as the light-sensitive material. But over the sensitive lead surface is spread a layer of silver metal only one atom thick. When this combination emulsion is exposed, a complex chemical reaction takes place, and the lead compound destroys the silver layer where the most light has hit it. After processing, dark areas appear where there has been the least exposure, and light areas remain where there has been the most exposure. This is just the opposite of what happens when conventional film is processed, and thus it produces a positive image instead of a negative one. However, the emulsion will not work if there are even slight variations in its chemical content, making production difficult and costly.

The problem of replacing silver has been solved in one system—Kalvar —that substitutes tiny particles of a nitrogen-releasing compound as the image-forming factor. Sensitive only to ultraviolet light, the compound when exposed releases its nitrogen molecules in microscopic bubbles, which form a latent image. When the film is heated, the bubbles expand but remain trapped within the compound, forming a visible image. Kalvar's drawback is that it requires a powerful ultraviolet energy source to coax the particles in the compound into releasing the bubbles. Even so, Kalvar already is employed for reproducing aerial reconnaissance pictures, for duplicating images from microfilm and for copying any pictures taken on silver film. It might lend itself to adaptation in the home darkroom, however. The requirement of large doses of ultraviolet light could be met easily by strong lamps kept on hand for use in a photographic workroom.

Another imaging process that depends on ultraviolet light and produces images instantly without heat or wet chemicals is utilized by a product called Dylux. A paper coated with complex mixtures of photosensitive organic ma-

terials, Dylux produces a one-color image, the result of a chemical reaction set up by the ultraviolet light striking the organic compound. No development or fixing is needed and the image is visible and usable immediately after the exposure, which seldom requires more than 30 seconds. This material is now used to provide quick proofs of pages being printed by offset lithography (as the color pages in this book were). But it could be adapted to make positive proofs from photographs and transparencies. Dylux is also being field tested as a photosensitive aerosol spray. Possibly it could make photosensitive almost any surface—plastic, paper, glass, foam—that was sprayed with the emulsion. It also could be used to decorate products and clothing or by experimental artists seeking new ways to present images.

The ubiquitous office copying machine has been tried out by many experimenters—including office workers, on the sly—as a "dry duplicator" of photographs, without much success. The trouble is that the machines were designed to copy words, not pictures. For words, the machine need only have within its range sharp black and white, but photographs require that the copier register continuous tones, the ranges of grays between pitch black and pure white. But some progress has been made in developing similar machines that can reproduce the continuous tones of photographs. To copy a picture, it is placed in the machine and exposed onto an electrostatically charged plate or drum. The exposure reduces the static electric charge on the plate in proportion to the amount of light that strikes it. Particles of ink powder are attracted to the charged areas remaining on the plate. The image thus formed is physically transferred from the plate to a piece of paper by pressing the two together. Then the image is fixed to the paper, usually by heat. In a few seconds, out comes an acceptable copy of the original.

A more elaborate—and more expensive—copier of color images has also been devised. Like other copying machines, it uses a dry process and requires no silver emulsion. The machine (called a Color-in-Color) has the shape and bulk of a large office duplicating machine—about three feet high, four feet long and two feet deep—and it costs around $10,000. But in 30 seconds it turns out full-color copies of pictures, and one model produces fivefold enlargements of transparencies. Colors can even be added arbitrarily by the operator to black-and-white picture reproductions. The original, when placed in the machine, is scanned three times by a beam of light that makes three color separations for three primary colors. The colors are produced by powders that are transferred to the copy paper in amounts that can mimic the original picture. Since the strength and tone of the colors can be altered by a push of a button, the operator exercises complete control over the process. In this way he can color a black-and-white picture in whatever

combination of colors he wishes. Even three-dimensional objects can serve as originals from which copies can be made. A photographic collage can be put together, for example, from ribbons, colorful scarves, vegetables, eyeglasses, wallets, anything handy; all are recorded in color in the print.

Another new color system, called colography, can print a bright picture on almost any hard surface. Designed to make color proofs so publishers can see how a picture will look in print, colography can be used with a great number of inks and materials for a variety of purposes. The surface to be used —paper, plastic or metal—is coated with an organic compound that responds to ultraviolet light. After exposure to a negative, a powdered ink or dye is rubbed into the surface with a cotton applicator. This imbeds particles of the powder in the exposed areas of the surface, while the unexposed sections reject it. The excess powder is then removed by an air blower and the image is revealed.

Photographers—and artists—have commandeered some of these new imaging systems to create interesting pictures on unlikely surfaces. Liquid emulsions, which in the last century were spread on glass to make photographs, are now used to transpose decorative pictures onto everything from living-room walls to belt buckles and neckties. The technology that is leading photography into new ways of picturemaking is also opening up creative frontiers in the visual arts, as may be seen in the following sections on printing techniques and darkroom manipulations. □

Offbeat Printing Techniques

In the hands of an imaginative photographer some basic materials of the printing industry can transform a single black-and-white picture into a series of strikingly dissimilar variations on a theme. The pictures on the following pages illustrate one photographer's methods of using such materials to convert the conventional portrait at right into a silhouette, a line sketch, a posterlike patchwork of grays and then into two color versions.

As a starting point, the photographer enlarged his original negative onto lith film, a high-contrast copying film made by several companies under different trade names (Kodalith, Gevalith, GAF P-407) for use in photo-offset printing. One of its special properties is that it changes all the grays into a stark transparency of black and white, with no intermediate tones. Because it converts pale tones into pitch black and dark ones into white, lith film can render invisible any slight smudges in a page of type that is being copied for a printing plate. The same property enables the graphic artist-photographer to convert any continuous-tone picture, made on ordinary film, into a pattern of pure

black and white. And by altering the exposure time in the copying process, one can produce images with differing amounts of black—even to the extreme of a practically solid-black silhouette pierced only by the brightest highlights.

Because lith film produces black-and-white transparencies, several can be superimposed in printing to achieve a range of effects *(pages 68-71)*. It lends itself to various color-printing techniques. One is the ancient stenciling process known as silk-screen printing. The others are more modern, utilizing color printing paper or a pigmented sheet film that creates flat ungraded patches of color.

Step-by-step demonstrations of techniques for using these materials appear on the following pages. The results display what a broad range of unexpected and evocative images the photographer can achieve. Photographer Fred Burrell, who made all the pictures in this series except the one on page 77, advocates experimentation rather than always attempting to plan effects in advance because, as he puts it, "the imagination is not always so daring as the accident."

The starting point for a series of completely ▶ unconventional pictures was this conventional studio portrait of a fashion model, shot with a 2¼ x 2¼ single-lens reflex camera on medium-speed black-and-white film. Its clarity of line and subtle shadows suited the portrait to a wide variety of transformations with high-contrast copying materials in the darkroom and the studio.

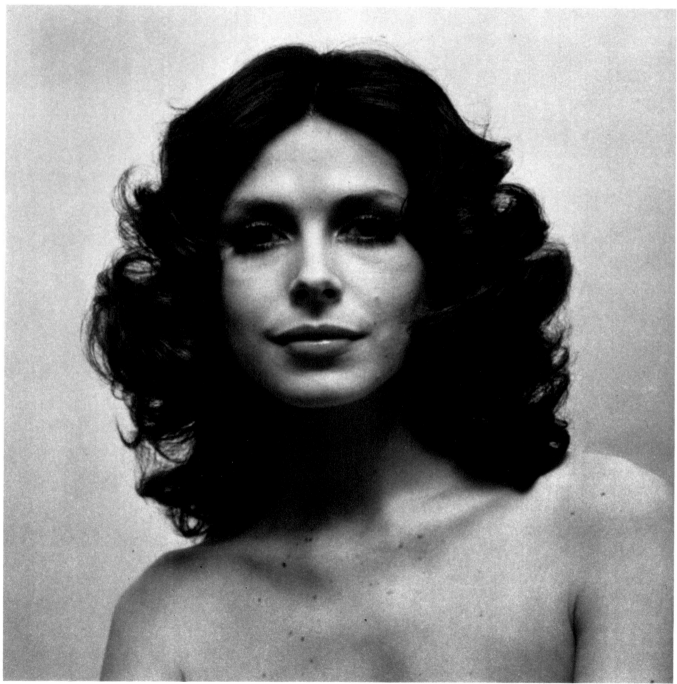

FRED BURRELL: *Portrait of Ann Ford*, 1971

To start off the printing processes shown on these pages, place the original negative within the enlarger's negative carrier, ready to be inserted in the enlarger for reproduction on high-contrast copying film. The first reproduction will be a positive transparency and from it a negative will be made; several such copies may be needed in order to produce the desired final results.

The negative, projected onto the easel on the baseboard, is enlarged to fill an 8 x 10 sheet of copying film. An exposure time between 10 and 20 seconds generally gives a usable copy, but experiment to get the desired image—longer exposure extends dark areas, reducing detail.

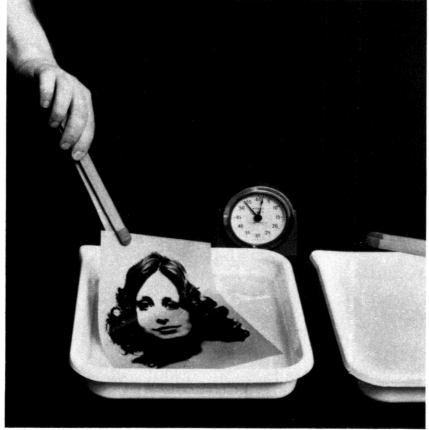

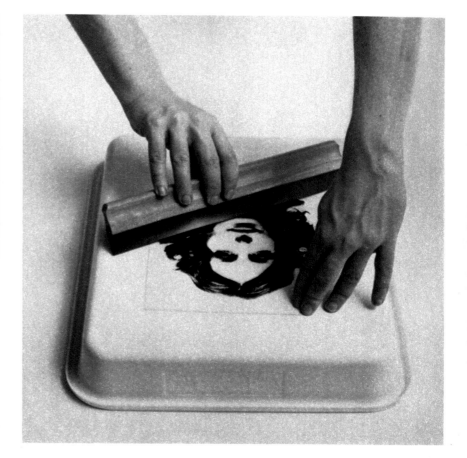

After developing the film for 2½ minutes in the special solution sold for it, lift it from the solution with tongs and transfer it to the stop bath (in the tray at right). Leave it in the stop bath for about 10 seconds, agitate it in the fixer tray for about four minutes, and then wash the print for 10 minutes in running water at 65° to 70°F.

Draw a squeegee across each side of the wet positive—placed on the bottom of an upturned tray—to wipe most of the water off. Then hang the positive up to dry, after which a high-contrast negative can be made from it (following pages).

A negative can be produced from a positive transparency by using standard contact-printing techniques: clip the positive to the glass cover of a printing frame, emulsion side away from the glass. Then lower the cover onto an emulsion-side-up unexposed sheet of high-contrast copying film already inserted in the bottom of the frame.

Before turning on the enlarger lamp's timer control, make sure that the negative carrier is empty, so that the lamp's light will not be impeded. An exposure between 5 and 10 seconds is usually correct, but several tests may be necessary to get dark areas (corresponding to light areas in the original portrait) dense enough. These dark areas should come out solid black.

The negative and positive transparencies, ready for use in the printing processes demonstrated on the following pages, are both unshaded and flat. Artistic control over the image up to this point is possible only while the positive is being made, when exposure can vary the size of the dark areas; the negative is simply an exact duplicate in reverse. The positive in this pair has been turned over, or flopped, reversing left for right in its normal image, to demonstrate the congruence of light with dark areas in positive and negative.

Before making a line print—a photographic image composed solely of dark lines on a white background or white lines on a dark background—get rid of "pinholes," which are transparent specks created by dust when copies are made. They may be painted out with a fine brush dipped in a gooey blocking-out material called opaque.

Next, place the positive and negative over an illuminated viewing screen (or simply hold them up to the light) and carefully align them so that the two images exactly overlap. The result, looked at straight on, will be solid black. However, light can pass through the two copies obliquely, along the outlines of the paired images. Tape the copies together into a sandwich and clip it into a printing frame over an unexposed sheet of copying film.

An ordinary record player rotates the frame so that light can come in obliquely from all sides to expose the line image. Pieces of cardboard raise the frame above the top of the spindle. First switch on the turntable, then the light source—a 100-watt frosted lamp placed three feet above the turntable at a 45° angle. If the printing frame rotates at 45 rpm during a 15-second exposure, the result will be like the image at right.

The line picture—a thin black outline of the subject on clear film—resembles a pen-and-ink sketch. After drying, it can be copied directly onto another sheet of high-contrast film to make a clear-line-on-black-background transparency. Either image can be printed on printing paper to make an opaque, white or black line image.

Posterization gives an image with distinctly separated grays, or colors that look like the flat shades of poster paints. The image above was made from the three high-contrast copies at left: two positives plus a negative made from a third positive, each having different dark areas. The three were carefully aligned, then fastened with tape hinges (above, left) so that each positive could be laid over or lifted away from the negative. The negative at the bottom of this stack was then taped on two sides to the enlarger baseboard. Printing paper was slipped under the untaped sides, and three exposures were made. The first exposure, for 60 seconds, was through all three copies and gave the black tones of the final print. Then the medium-area positive was flipped back, and an exposure of one second was made through the small-area copy and the negative so as to start the dark gray tone. A final one-second exposure through the negative alone gave the light gray and completed the dark gray.

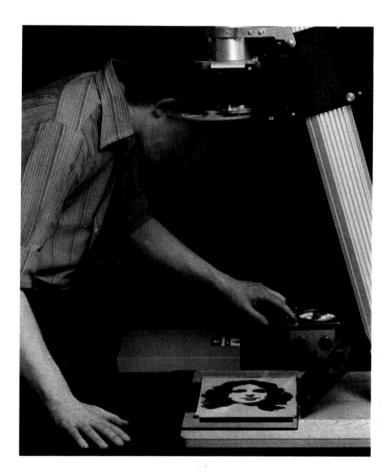

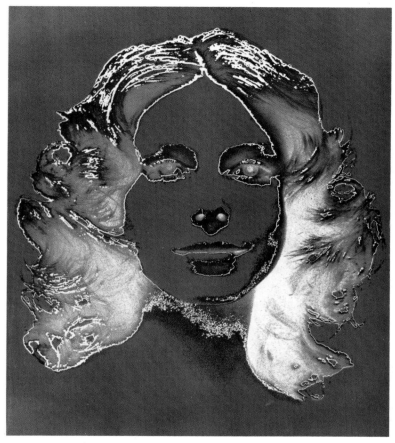

The starting point for the color posterization shown above is much the same as for the black-and-white example on the opposite page—high-contrast copies, one negative and two positives of unequal dark areas—but the line image shown on page 69 is also used. The color is introduced by inserting a color filter into the enlarger's filter drawer, and shining the colored light through the copies onto a sheet of the color-printing paper (ordinarily used with color-negative films), all held flat under a glass sheet (above, left). For this posterization, the line print and the small-area copy were used for an exposure with a blue filter, to get yellow. The medium-area copy was added next and three exposures were made—through red, green and blue filters—for 3, 5 and 6 seconds respectively. The resulting color, mixed with the yellow, gave the russet hue. The final exposure, with the negative copy added, was through a red filter and produced cyan, which gave the greenish cast that is most visible in the features of the face.

The black and white areas of copy transparencies can be given uniform color by printing them with the "diazo" materials used by display artists. There are several types of these materials —Transparex, Color-Key and Color-Guide, for example—and each is manipulated in much the same way.

The picture was created from the portrait shown on page 63 plus a profile of the same model; the profile was used both normally and flopped. Three positive transparencies having dark areas of different sizes were made on high-contrast copy film from each of the three views. One negative was made from each set. The positives and negatives, in various combinations, were then printed and superimposed: two dark blue, one magenta, one yellow, two cyan, two green and two orange.

Place between two glass sheets: yellow paper (to stop light bounce); the diazo sheet, coated side down; the copy transparency.

After a 90-second exposure to the ultraviolet of a photoflood, place the sheet, coated side up, on a glass set on wood strips in a developing tray.

Now pour a generous amount of the special developer over the exposed sheet. The excess developer will run off the glass into the tray.

Swab the sheet lightly with tissue to remove color coating from the unexposed areas. Rinse the sheet carefully with water and hang to dry.

Working over a lighted screen, tape the sheets together to get the effect desired, such as the overlapping outlines of the composite at right.

VERNON REGIONAL
JUNIOR COLLEGE LIBRARY

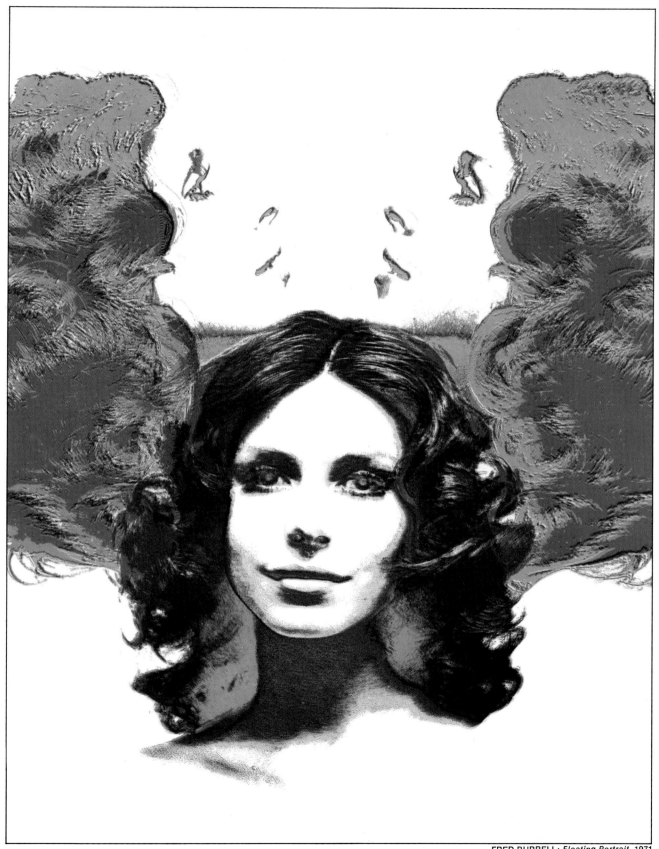

FRED BURRELL: *Floating Portrait*, 1971

73

Making a Silk-Screen Picture

The procedure shown on this and the next two pages is a photographic adaptation of a method that Asian craftsmen have used for centuries in duplicating designs. It involves cementing a stencil to a screen drawn tightly over a frame, placing the screen on a surface that is to be printed, and running ink over it. The ink is forced through the screen where the stencil does not block passage, printing a positive of the negative image on the stencil.

The Asian craftsmen used handmade stencils and screens of silk; for silk-screened photographs the screen may be wire or synthetic fabric and the stencil is made by copying a high-contrast transparency onto a gelatinous sheet called silk-screen film, which becomes insoluble where it is struck by light. Silk screening allows the photographer to put the basic image—in colors limited only by his imagination and supply of inks—onto almost any surface from a shoebox to a sweat shirt.

The gear for making a silk-screen print is available at art-supply stores. Needed are: a ready-framed screen; hinge clamps for positioning it; silk-screen film, like the Blue Poly-2 used here, for making the stencil; a squeegee; plus inks and chemicals. The screen must be thoroughly cleaned before each use, to ensure that the stencil adheres tightly to it; use household cleansing powder and water, rubbed on with a rag (never a brush), and carefully rinse it off. The stencil used for this demonstration was made from a Kodalith positive cut into 10 strips of equal width. The strips were separated and held in place with masking tape. The whole composition was then ready for use in making the stencil.

On two-inch-thick foam rubber covered with paper, place the silk-screen film (emulsion side down), the positive and a sheet of glass.

Expose for about 16 minutes under a No. 2 (500-watt) photoflood bulb in a reflector hanging about 18 inches above the silk-screen film.

Immerse the exposed film (emulsion side up) in cool (less than 75°F.) stencil developer. Agitate it in the developer for two minutes and remove.

Washing gently in warm (about 96°F.) water melts away unexposed areas of the emulsion, leaving a stencil impermeable to ink in the exposed areas.

After hardening stencil in a cold-water rinse, lay it on cardboard for better contact with the screen. Hinge clamps will keep screen in place.

Place the screen over the stencil, emulsion side up, and blot it gently with paper towels until most of the excess water has been picked up.

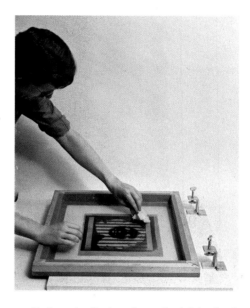

To keep the film from becoming brittle after it dries, wipe a thick coat of glycerin solution onto the stencil and leave it on for five minutes.

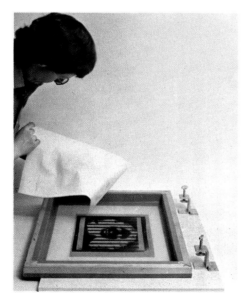

Blot glycerin with paper towels until no stencil color comes off. Remove the cardboard. Let the stencil dry, then peel off its backing.

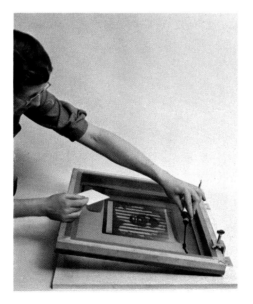

Around the stencil's outer edges spread "blockout," a viscous solution that keeps ink from going through the unstenciled margins.

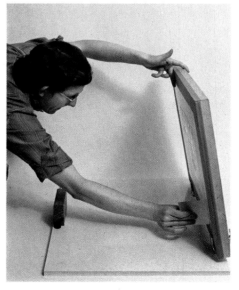

To speed up the coagulation of the blockout, scrape off any excess solution that seeps through onto the underside of the screen.

The material which is to be imprinted should be accurately aligned with the stencil for each application of a color. Pieces of masking tape affixed to the work surface serve as stops for positioning the material so that in successive inkings the image will not shift.

After printing is completed, it is important to remove all ink before it dries and clogs the mesh. Use whatever solvent—turpentine, mineral spirits, water —that is appropriate for the ink employed. After the ink is dissolved, the stencil may be removed by running hot water over it and gently scraping it off; the screen is then ready for re-use.

It is also important to throw out any mixed stencil developer that is left over: if kept in the air more than a day it spoils—and if kept in a bottle it will form a gas and may burst the bottle.

After the blockout has dried to form an impermeable border around the stencil, tighten the hinge clamps to secure the screen.

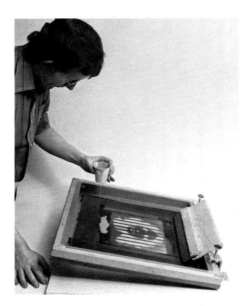

Tilt the screen up slightly and slip a wood block underneath to keep it slanted up. Pour a little ink into the near side of the screen.

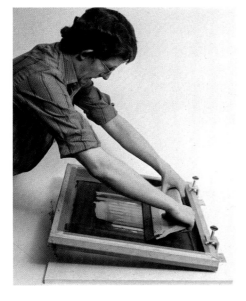

Working from near side to far side with a firm but light stroke, squeegee the ink over the screen, so that the stencil is completely inked.

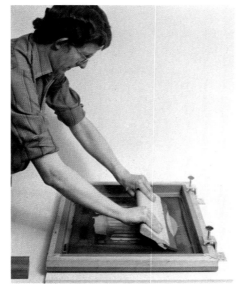

After placing the matter to be printed under the screen, remove the wood block, lower the screen and squeegee the ink forward, pressing down.

Raise the screen, remove the imprinted material and let it dry. Once it is dry, other colors are applied in the same manner shown on this page.

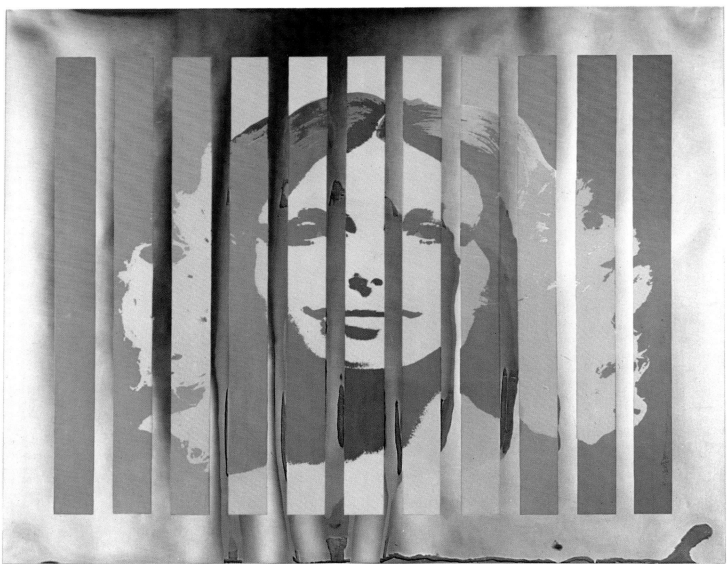

RONI HENNING: *Girl in Cage*, 1972

The final print is a fine example of the exciting images the silk-screen process can produce. Roni Henning used two stencils to make this print, one to put color in the highlights of the face and in parts of the background, and one for shadows and hair. She taped heavy paper onto the underside of the screen to mask parts of each stencil, so that she could color one or two stripes at a time on the mirrorlike Mylar plastic printing surface.

Innovations from the Darkroom

The goal of most photographers—to get from the darkroom a crisp, clear print with good detail—is shared by none of those represented on the following pages. Each in his own way deviates from the norm to create images that are forceful, beautiful and sometimes funny. (Catherine Jansen's roomful of blueprints, shown on pages 92-93, is full of such humorous contrarieties as a limp radio, a languid comb and a two-dimensional brassière with a three-dimensional hook.)

For several of these photographers the transformations begin even before they expose their film. Bill McCartney, on the facing page, sets the stage for his burnished-looking portraits by using a high-contrast negative and dramatic lighting; René Groebli produces contrasty transparencies as raw materials for garishly colored portraits like the one on pages 94-95. Larry Bach prepared for his progressive abstraction *(pages 82-83)* by first painting a cluster of gourds white, reducing them to unidentifiable shapes.

For the most part, however, these transformations happened in the darkroom and deliberately break the rules of darkroom procedure. Developer applied at the "wrong" stage and in overabundant amounts helped produce the startling effects at right, and Nick Amplos' reticulated print *(page 84)* got that way from being overprocessed to the point of graininess and then dunked in warm water. Barbara Blondeau's heightened images of urban life *(pages 86-87)* and Joanne Leonard's internalized dream images *(pages 88-89)* both take off from a common source: they were printed on film instead of paper, the clear areas backed up in one case by paint, in the other by bits and pieces of dream-associated material.

In many of the prints more than one technique goes into the final result, and often the same technique serves two printmakers quite differently. Perhaps the most unusual sort of print manipulation in this portfolio is that performed by Joan Redmond, who retrieves her spoiled, stuck-together prints from the wastebasket and assembles them into kaleidoscopic images *(pages 80-81).*

This eerily lighted portrait of a man and woman was produced by printing and developing the picture simultaneously. The photographer began with a high-contrast negative and high-contrast printing paper, onto which he enlarged the image slightly out of focus. He saturated the printing paper with developer, then switched the enlarger light on and off and added more developer. He repeated this process until he had achieved the desired effect of light and shade; then he put the print in the stop bath to halt chemical action.

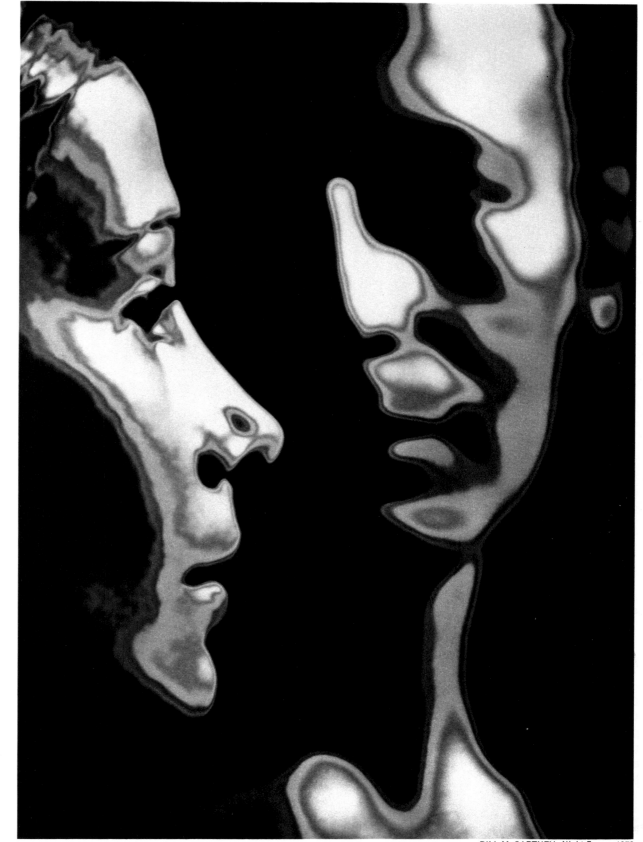

BILL McCARTNEY: *Night Faces,* 1970

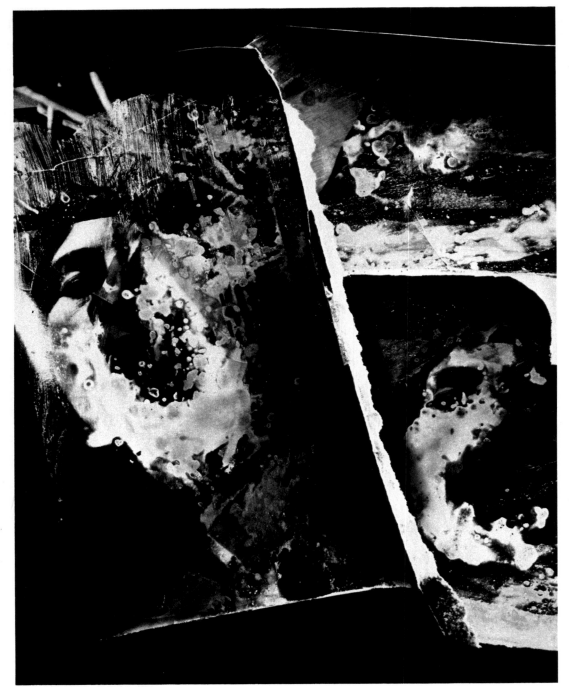

JOAN REDMOND: *Untitled,* 1971

Most photographers throw away the prints they spoil, but Joan Redmond keeps hers—and in fact deliberately spoils perfectly good prints. For the print at left, she took three close-up pictures of one girl, developed them and then threw the unfixed prints in the wastebasket, where they stuck together. She then pulled them apart and splashed a bleach, potassium ferricyanide, over them, drawing a brush through the chemical to create the scratchy-looking lines. Finally she reassembled the ruins into a strange, fascinating collage and rephotographed it.

For the print at right the starting point was two strips of 35mm negatives taken with a fisheye lens. Miss Redmond enlarged the negatives, sprocket holes and all, onto 11 x 14 printing paper. Then she projected onto the partially exposed print two shadows by first placing her hand, then her face, on the printing paper. Next she dribbled and streaked developer over it. She threw the print into the wastebasket where it got torn *(top center)* and bent *(top left).* Finally she rephotographed the mottled print, which bears only faint traces of the original images: at lower left, the porch of a house; at lower right, a boy; at upper right, a picture of another photographer.

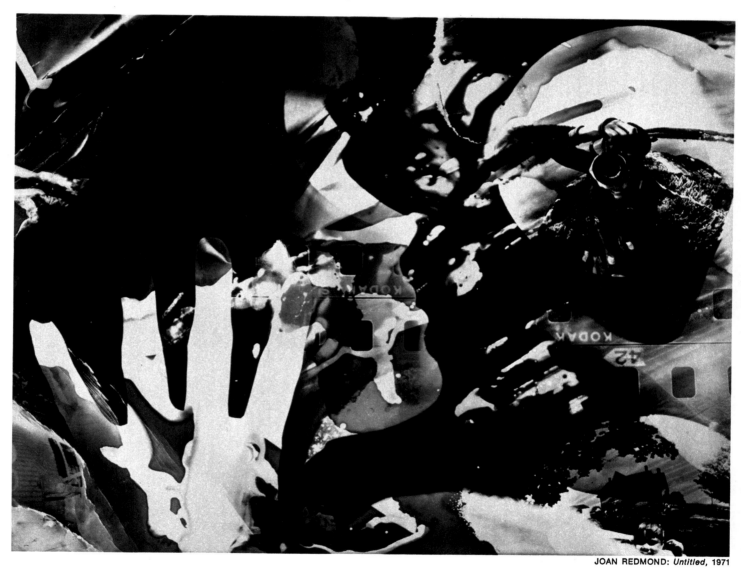

JOAN REDMOND: *Untitled*, 1971

Photographer Lawrence Bach, who has made use of a combination of darkroom techniques and manipulations to create his designs, sees the panel at right as "part of a gamelike progression" in which the viewer's eye moves across the board from a grouping of recognizable forms of nature to a nonrepresentational study in black and white.

The natural elements in the photographs are rubber-plant leaves, gourds, sea water and sand. But Bach sprayed the leaves black and the gourds white to obscure their natural colors and textures, and to intensify the contrasts in their shapes. Over a three-month period, he made hundreds of shots of the gourds and the leaves as they were lying on the beach, bobbing in the sea and resting on a sheet of plexiglass. From meticulously drawn plans and paste-ups he arranged and rearranged selected prints in different positions, sizes and densities. Then, with these artistic "blueprints" as guides, he used a variety of photographic techniques to multiply images and alter tones. In the final result the natural objects, recognizable albeit contrived-looking in the first panel, are obscured in the abstract design of the complex assemblage at the far right, where the divisions between the prints are lost and the objects exist only as parts of a design.

LAWRENCE BACH: *Untitled*, 1971

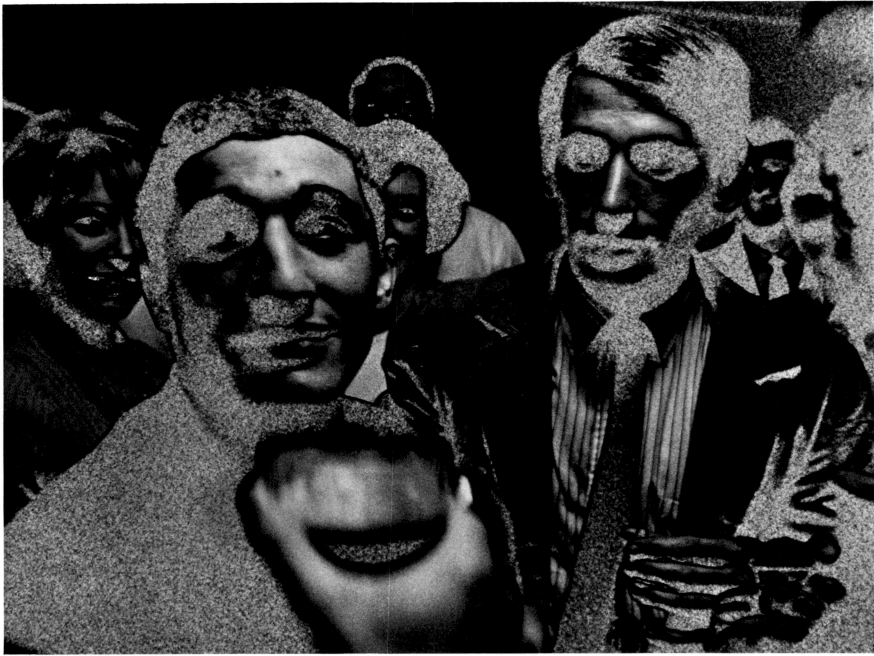

NICHOLAS AMPLO: *Rugby Party*, 1965

TOM PORETT: *George and I*, 1971

To achieve the not-dissimilar tone reversals at left and above, Nicholas Amplo and Tom Porett took very different routes. Amplo started with a straightforward black-and-white shot of rugby players at a party, then committed three darkroom "errors." He made the negative abnormally grainy, dark and contrasty by developing it longer than the specified time in a solution warmer than specified; he reversed its tones by solarizing, exposing it to a white light before it was fully developed; and he achieved the mottled look, reticulation, by washing the negative in water at 125°F.

Porett's multiple exposure, showing a friend (the large face in the center) and himself (the smaller figure within the face), began as a color transparency that he printed on equidensity film *(pages 20-21),* which responds to only a single intensity of light, ignoring all others. In this case the response was determined by the exposure, the various densities and colors in the transparency, and by the color sensitivity of equidensity film. Porett then copied the equidensity print onto color film, creating the translucent picture above.

BARBARA BLONDEAU: *Untitled*, 1970

The somber students above and the glittering cars at right are examples of Barbara Blondeau's special interest in the power of the stark black-and-white photograph. The students are peace marchers; the cars on a street in Philadelphia are gaudy objects that enliven the scene as much as any shopwindows could do. In each case the print is an edited, intensified version of reality.

To achieve her effect, the photographer first sharpens and simplifies the original image by making a print on high-contrast film, thus getting rid of most of the intermediate grays. Then she fills in the black or white areas of the transparency with various background materials.

The faces of the marchers and the spotted dog in the foreground were painted from behind in flat white; the selectively opaqued transparency was then mounted on a gray paper background. The lighter areas in the picture of the cars were sprayed gold, except for the street signs and the man's head and arm, which were painted white. A shiny black enamel was sprayed over the darker sections to make the silhouette effect even more pronounced.

BARBARA BLONDEAU: *Untitled*, 1970

Like Barbara Blondeau, whose work is shown on the preceding pages, Joanne Leonard takes a positive transparency as the starting point for her eerie prints. But instead of reducing the pictorial image to bold essentials, she builds it up from the back with various materials, to complicate and enrich its meaning.

In these two examples the subject is dreams, and the vehicle for exploring them is the sprawling figure of a man (the photographer's husband) asleep in the heat of a Mexican hotel room. At near right, the background dream image is a photograph of a snowy woods. It flickers behind the superimposed transparency like a gauzy veil, patterning everything except the man's body, the picture frame and the embrasure and frame of the window. These parts of the image, opaqued in tones of gray and off-white, are in effect the picture's touchstones with reality.

In the picture opposite the dream material is more complex and only the man's opaqued figure looks literal. Showing through the bed is a reproduction of a Persian textile; in the picture frame on the left-hand wall there appears a snapshot of the photographer and her husband. Beyond the window is a reproduction of a painting of the Hindu god Krishna and his consort astride a mythical bird. A thin tan wash softens the walls and window frames to make the scene even more dreamlike.

JOANNE LEONARD: *Sad Dreams on Cold Mornings*, 1971

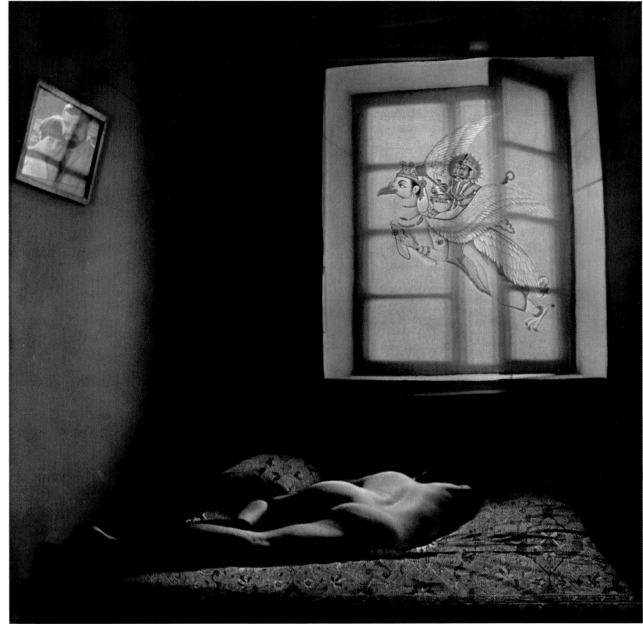

JOANNE LEONARD: *Lost Dreams*, 1971

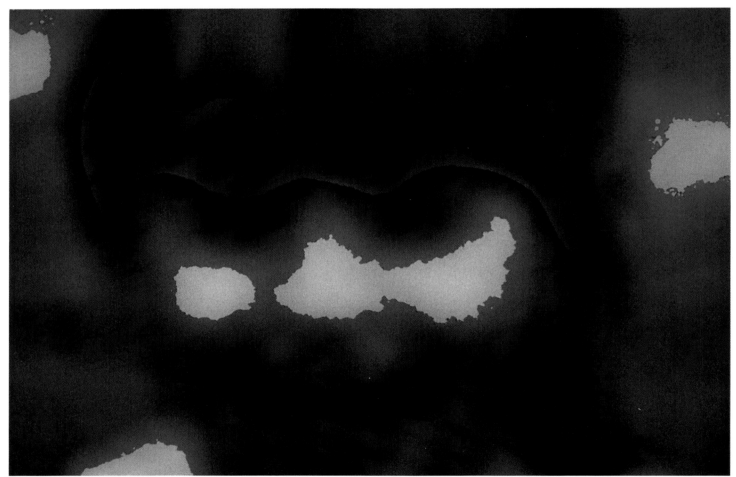

TOM PORETT: *Jennifer,* 1971

The pictures on these pages are portraits—or were, until turned into bizarre studies in color combination in the photographer's darkroom.

A number of steps were involved. The images were made in color, contact printed on black-and-white equidensity film *(pages 20-21),* printed on flat-color diazo sheets *(pages 72-73),* then assembled for rephotographing.

The example above may look like only an arrangement of colors when viewed close up, but if the book is held at arm's length it yields a portrait of the photographer's five-year-old daughter. The human image appears and disappears because the original transparency was taken with a soft focus; the demarcation between colors was sharpened both by the equidensity film

and by printing it on diazo sheets.

Porett used the same printing methods to get the photograph at right, a portrait of a friend at a lakeside, but he took the original photograph with a half-frame camera, which makes two pictures within the space occupied by one 35mm frame, and deliberately distorted the images by means of a special plastic auxiliary lens.

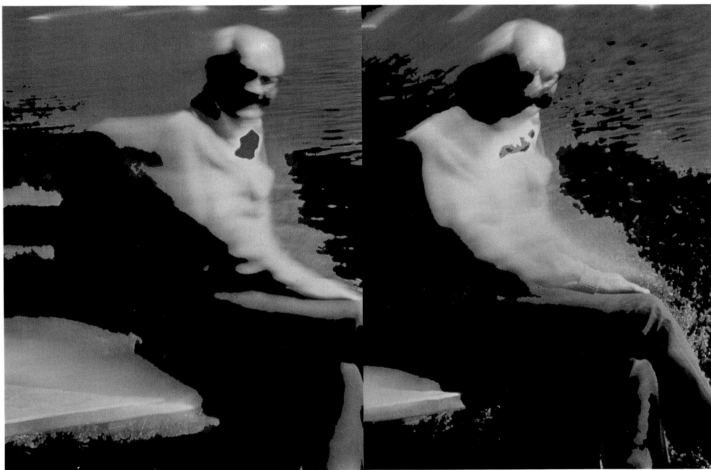

TOM PORETT: *Waiting for Alistair*, 1971

CATHERINE JANSEN: *Radio Shelf in the Blue Bedroom,* 1971

Except for a few things, none of the contents of Catherine Jansen's *Blue Bedroom* at right is real. The room is real, and so are the bed and fringed bedspread, the three-legged table and the electric cord. But for the rest, the room is filled with synthetic furnishings that make it a three-dimensional work of art sometimes called environmental sculpture. The sleeping figures, the light switch on the wall, the contents of the bedside shelf *(shown in close-up above),* the TV picture, the crumpled *New York Times,* the sneakers and slippers and slip and brassière dropped casually on the floor—all are photographically reproduced.

Miss Jansen refers to her work as soft sculptures. She begins with a print —of a positive, a negative or a shadow picture, or photogram—made on fabric. To sensitize the materials she dips them in blueprinting solution, the kind used for engineer's blueprints, and exposes them almost as soon as they are dry (the solution quickly loses its sensitivity to light). The "people sheet" was made by spreading a sensitized bedsheet outdoors and having two people lie on it; the pillowcase pictures of his-and-her dreams were printed from strips of negatives. To stop the printing process, she washes the exposed fabric in clear water.

Most of the soft sculptures have some sort of dimension, but it is never quite real: the comb has front and back but no bulk. Here and there bits of reality have been added to the blueprints: the eyelets in the sneaker picture are silver embroidered, the brassière photograph has a real hook and eye, and the perfume bottle on the wall shelf was sprayed with real fragrance.

CATHERINE JANSEN: *Blue Bedroom*, 1971

RENÉ GROEBLI: *Aja Iskander Schmidlin,* 1969

Photographer René Groebli's "communicative portrait" of his subject, painter Aja Iskander Schmidlin, is a composite of the artist and his style. Parts of it come from photographs of Schmidlin himself—the head, and the hand holding the brush. Other parts of it are photographs of painterly things—such as the white canvas background, the coarse texture on the arm. All of it, in fact, is a series of images put together in the darkroom.

To construct this print, Groebli used just about every darkroom technique in the book. He isolated primary hues from certain colors, transformed other colors (by enlarging a color negative through a "wrong" filter to change its color), fitted masks over previously exposed areas, and exposed a series of negatives in sequence onto a single print. In all, Groebli prepared 32 separate photographic reproductions so as to make seven transparencies, which he then combined to print the portrait —a photograph of Schmidlin in the latter's own palette and painting style.

ELEANOR MOTY: *Belt Buckle*, 1969

The same processes of photoengraving and electroplating that are used to reproduce pictures in newspapers and magazines can, in the hands of the creative photographer, transform images on film into metallic works of art—exquisite jewelry like that shown on these pages, and wall plaques *(overleaf)*. To make the belt buckle at left and the pin at right, Eleanor Moty began with high-contrast transparencies—for the buckle, a picture of tree branches, and for the pin, an 1850 photograph of schoolchildren in Dodge City. First the transparencies were contact printed onto sensitized sheets of silver. Development left an image in very faint relief. To deepen the relief, the pin was then etched in an acid bath; the belt buckle was etched first in a mild solution and then electroplated with copper.

A somewhat similar etching process was used by Naomi Savage, creator of the giant photoengraved murals in the Lyndon Baines Johnson Library in Austin, Texas. To produce the wall plaque on the following page, an 11-by-14-inch piece showing a series of abstracted figures on horseback, she first printed a shadow picture, or photogram, of a plastic horse and rider from a child's drawing kit. She made multiple exposures of the figures, then had an engraver transfer the print onto copper. Finally she silverplated the copper herself, oxidized it to give it a patina and coated it with lacquer.

ELEANOR MOTY: *Dodge City Schoolhouse,* 1970

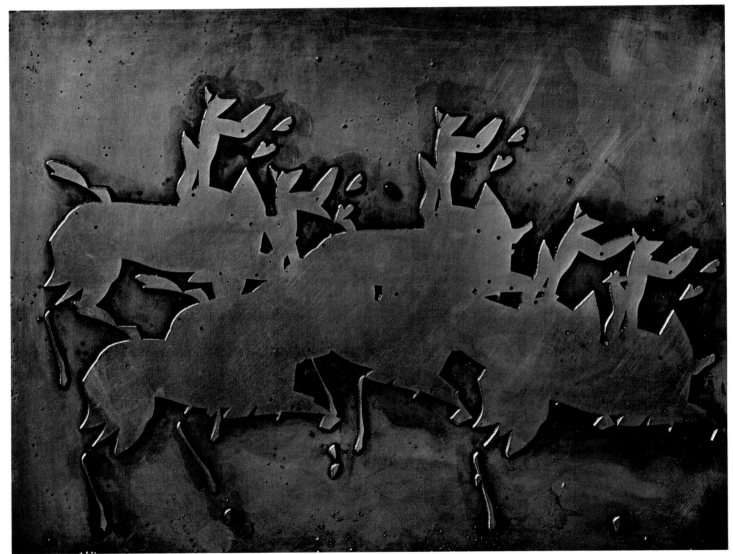

NAOMI SAVAGE: *The Chase,* 1967

Mixing the Media 4

ELVIS PRESLEY 39

RAY JOHNSON: *Elvis Presley No. 1,* 1955

An Interplay between the Arts

When artist Ray Johnson whimsically altered a photograph of rock 'n' roll singer Elvis Presley *(page 101)*—painting red teardrops spilling down one cheek and pasting bits of paper to one side of the print—he reintroduced photography to the wider world of art, and he pointed the way to a whole new field of exploration for photographers. He called his creation *Oedipus* (a title he later changed) and declared: "I'm the only painter in New York whose drips mean anything."

Many another painter besides Johnson was becoming surfeited with Abstract Expressionism, the school of modern art based on drips, blobs and smudges that—although they meant something to the artist—were indecipherable to most other people. When the reaction against such cryptic abstractions set in, the camera and the photograph played a vital role. So did the technique that Johnson had used as a visual trick—the joining of photography and painting. Combinations of photographs—or of mechanical reproductions of photographs—with other media of expression began to be used by many avant-garde artists. The imagery of the painter's and sculptor's arts was abruptly broadened to include pictures from magazines and newspapers, cinema and television—the visual fare most familiar to the public. And these experiments were demonstrating possibilities in photography that photographers by and large had missed.

The interplay between photography and the other arts, while it looks novel, actually goes back more than a century. Photography had no sooner been invented than the question arose as to whether it was an ally or a threat to the fine arts. In a few years the French critic Théophile Gautier, reviewing an exhibition of paintings at the Paris Salon, was to make the tongue-in-cheek proposal that a special medal be awarded to the daguerreotype as the unacknowledged collaborator that had "worked hard" in helping many artists represented there.

By the end of the 19th Century painters were commonly painting from photographs of models; but more than that, photography was suggesting new points of view in art. Edgar Degas, a master of the Impressionist school and himself an amateur photographer, avidly studied photographs to understand motion, the better to render his ballet dancers and horses. Decades later, the multiple exposures of moving figures photographed by the French physiologist Jules Etienne Marey inspired Marcel Duchamp, later a leader of the Dada school, to paint his *Nude Descending a Staircase,* one of the most revolutionary art works of the 20th Century. In the 1880s Marey had delineated the limbs of his models with long strips of white cloth, which appeared in his photographs as overlapping sticks—the same effect that Duchamp was to achieve, with such repercussions, in his celebrated painting made in 1912.

But Ray Johnson's manipulation of the Presley portrait was something

new; it went beyond the use of ideas from photography to merge the very materials of camera work and paint. The photographic image contributed a sense of actuality—after all, the camera does not lie—and the use of that image was a harbinger of a new realism that was to mark painting. The new wave was born of Pop Art, that deadpan, sarcastic movement that had its prophet in Johnson and its father in Andy Warhol, the silver-haired, dark-spectacled, leather-jacketed supercelebrity who turned precision drafts-manship (he had formerly made a good living at commercial illustration) into a new art form. In one playful mood he turned out meticulously painted, out-sized versions of Brillo boxes and Campbell soup cans; in a more serious vein he produced silk-screened repetitions of photographs of such heroines of the decade as Jacqueline Kennedy, Elizabeth Taylor and Marilyn Monroe.

Many of Pop Art's features have proved desirable: the use of familiar subjects; the adaptation of images already manufactured by the camera and reproduced in daily papers and magazines; the repetition of such images in groups. They exploit for the artist's own purposes the public currency—the images that assail the eye and influence the thoughts of everyone who reads a paper, watches television, goes to the movies, and shops from supermarket shelves. For the artist too is affected by this plethora of images; when he paints or sculpts, he uses photographs on the principle that they are as worthy of his attention as a Grecian urn. "Art is what things become when you use them," says Robert Rauschenberg *(pages 106-107).*

The ways in which painters and sculptors "use things" today are as varied as their signatures, but without exception the works shown in this chapter use photography—employing the everyday, recognizable image and taking advantage of photomechanical technology in creating both two- and three-dimensional assemblages. Having embraced photography as an element in their work, artists now use it with a freedom that has revitalized the media of expression that, some once had feared, it might replace. Photographers already know the techniques involved; from their fellow artists they can gain a new perspective that can expand the horizons of their own medium. □

From Painters, a Different Tack for Photographers

While photographers have become increasingly enamored of the abstract *(Chapter 6),* artists of many different persuasions have been turning away from abstraction and toward realism in painting and sculpture. In the process great numbers of them have embraced photography in various ways. Indeed, pictures now serve as the raw material for a whole array of artistic media—for paintings, for silk-screen prints and lithographs, and even for sculptured forms in three dimensions.

Photographs are not always used exactly as they come out of the camera; commonly, as in the work of Richard Hamilton *(right),* they are used only in fragments—for one tack that the new realism takes is to rearrange the parts of the whole. Such fragments serve many purposes. They may be inserted in a picture simply to add variety—for contrast of tone, texture or concept. They may be placed there to give the scene complexity and jostle the viewer's imagination—or they may be there to simplify the message, as an economical way of suggesting a whole by its part. They may depict motion, interject the whimsical, suggest the paradoxical.

Other artists have other ways of using photographs. Some of them reproduce by silk screening *(page 108).* Others use a rubbing technique; Robert Rauschenberg *(pages 106-107)* once illustrated Dante's *Inferno* with copies of newspaper and magazine cuts, soaked in lighter fluid, placed on drawing paper and rubbed with a ballpoint pen to transfer the image. Says Rauschenberg: "I feel it's so wasteful not to use the images you find around you."

This view of the photograph as a ready-made image, to be manipulated like pigment or clay in the creation of a more complex work, is the essence of the artists' new approach. It separates them from picture-takers of the past, for whom a photograph was always the end product; it might be manipulated, transformed or added to, but it led inevitably to a result that was still a photograph. Such a restriction need not apply forever. What the cameraman does with his images is limited only by his own imagination, stimulated by examples such as those shown on these and the following pages. The results may or may not be designated photographs—but if they convey their creator's inner vision they succeed as works of art.

RICHARD HAMILTON: *Self-Portrait*, 1969

The portrait on the left consists of snippets of fashion photographs filled in with paint and cosmetics; the one at right is a partially painted face to which portions of photographs were added. In photographing the collages, the artist posed himself with his face appearing in the mirror hanging between what he calls Cosmetic Studies—a self-portrait of an artist with his work.

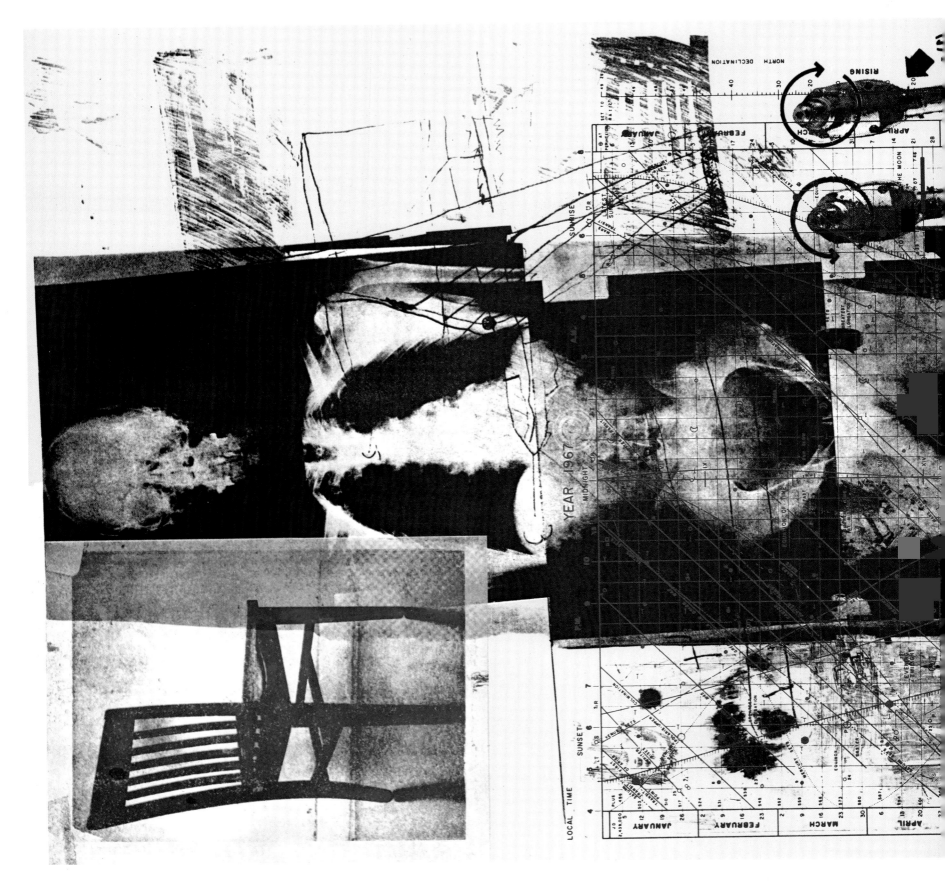

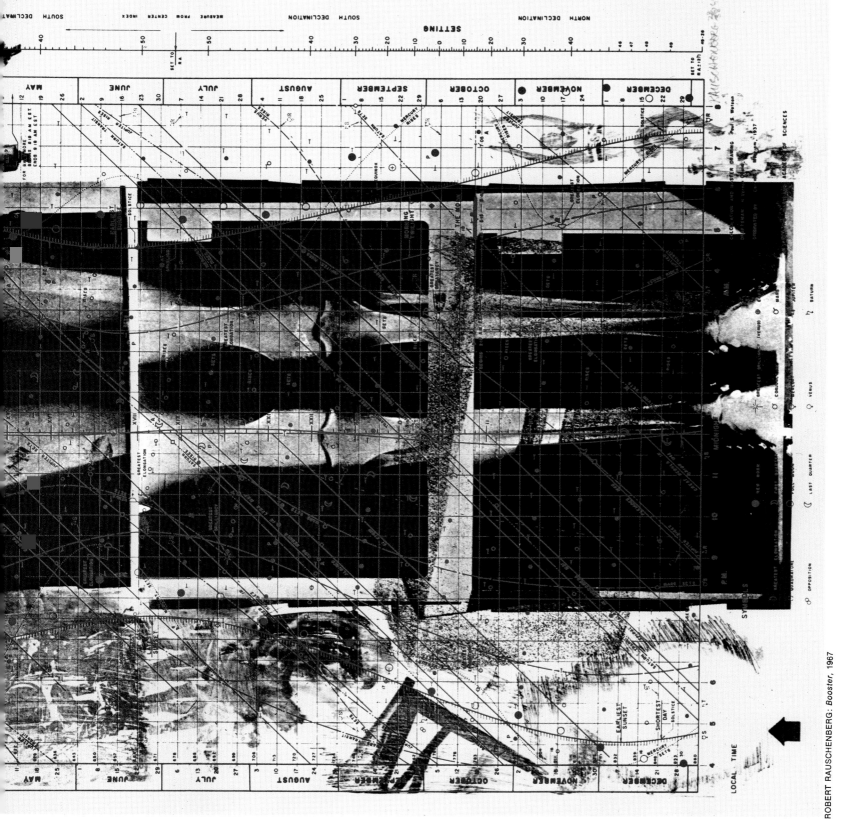

ROBERT RAUSCHENBERG: *Booster*, 1967

This lithograph, combining several kinds of graphic-arts techniques, is a stunning example of the way oddly assorted craftsmen—photographer, printer, doctor, lab technician—may join in the service of an artist. The painter began with a series of X-rays of

his own skeleton from head to foot. He added pencil drawings in his own hand (upper right margin), a picture of a chair (upper left), a cutout ad for hand drills (right center margin), rubbings that repeat some elements, such as the newspaper shot of an athlete

at lower right, and finally an astronomical chart silk-screened in red enamel. The assemblage was reproduced as a four-color lithograph on specially made rag paper. The title and, to some degree, the picture itself suggest a multistage rocket.

ANDY WARHOL: *Marilyn Monroe*, 1962

*What was originally a still from the movie
Gentlemen Prefer Blondes, later reproduced in a
fan magazine, becomes in the hands of artist
Warhol a poster evoking in flat, unnatural color
the beautiful and unhappy actress who for a
few years in the 1950s was every man's dream
girl. The poster is one of a series Warhol made
with the silk-screen method (pages 74-77).*

The trait that bound together the Pop artists of the 1960s was their imaginative use of the everyday image—mass-produced in newspapers, magazines, ads, billboards and television and seen in such profusion that it was familiar to everybody everywhere. Richard Hamilton *(page 105),* leader of the movement in Britain, and Andy Warhol, his counterpart in the United States, show here two ways of dealing with the same popular image, in this instance the celebrated Marilyn Monroe.

Warhol became famous for producing works with as little manual labor as possible; Hamilton has spent as much as three years on a single painting. The Warhol at left is a silk-screen print, made more or less mechanically, showing Marilyn's tentative smile as it was seen by millions. Hamilton worked meticulously with paint on a set of photographs *(right)* that had been taken by British photographer George Barris and evaluated by Miss Monroe herself, who X'd out three poses she did not like. "The aggressive obliteration of her own image," the artist says, had for him "a self-destructive implication that made her death all the more poignant."

A photographer's contact sheet (lower center), ►
*enlarged prints of the same scenes and some
added paint combine to call up a bizarre
suggestion of the character and fate of Marilyn
Monroe. The crosses and checks and the
word "good" are in her own hand; the artist did
the rest, symbolizing her suicide by painting
out her features in the print at the lower right.*

RICHARD HAMILTON: *My Marilyn*, 1965

"Nowadays," says the Italian painter Giosetta Fioroni, who made the double-image picture at right, "a slide projector is a normal piece of equipment —and I make use of it as I would any other artist's tool such as a spatula, oil color or brushes. In the same way that artists have used spatulas to spread paint, I now use a projector. In this picture I attempted to extract a significant photographic image from the sea of photographs surrounding us daily, and re-present it as a theme transformed into another element."

Like many of her contemporaries, artist Fioroni bases some of her work on "found" objects; but she sometimes creates her own images with the camera. In either case she uses a slide projector to transfer them to canvas, to be filled in with pencil and paint brush. She titled the picture at right *Double Liberty*. It is a play on words: "Liberty" is the term that Italians adopted around the turn of the century for the highly decorative flowing lines of the school known elsewhere as Art Nouveau. The London retail store called Liberty's used the style in fashion fabrics, and the Italians took the term from there.

The source of this painting was a positive transparency copied from an actress' picture in an Italian newspaper. Using a slide projector, the artist projected it in two different sizes onto a canvas coated with white. She traced the images in pencil, then painted over them in blue water-based paint, the flatness of which accentuated the stark, artificial-looking design.

GIOSETTA FIORONI: *Double Liberty*, 1965

Ever since the Renaissance, painters have wrestled with riddles about reality and reflections, and many have painted doubles of themselves and their subjects as reflected in mirrors. Michelangelo Pistoletto, a contemporary Italian painter, does his actual work on mirrors, thus not only multiplying the reflections in the picture, but also putting the very eye of the beholder among the beheld. Pistoletto's trick depends on his mounting—highly polished steel. He starts with black-and-white photographs, taken according to his instructions and enlarged to life size. The enlargements are traced onto tissue paper. He cuts the figure out, coats it with varnish or white paint, then paints in the image in oil; when he is through, it adheres to the steel. That in turn is mounted on a gallery wall, flush with the floor. The result is that the gallery is incorporated in the picture, and so are the viewers as they come and go. Mingling with the shifting reflections of the visitors, the painted figures take on a preoccupied, even melancholy air.

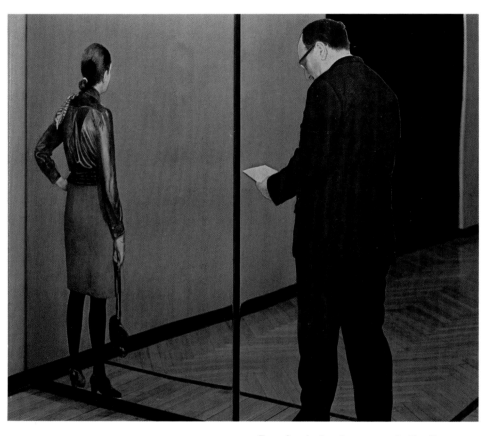

Two absorbed and uncommunicating figures are painted tissue-paper components of a collage executed by artist Pistoletto. The life-sized painted figures are stuck onto sheets of stainless steel that have been polished to a mirror finish, in which an art gallery and its furnishings are reflected. At right such a scene has been photographed from a position opposite the male figure, obscuring the photographer and his equipment except for a telltale shadow on the floor and wall. The photograph above was taken from a doorway, a vantage point that flattens the painted figures, making them look more like cutouts. If there had been live visitors present in the gallery when the photographs were taken, their reflections would have appeared in the steel.

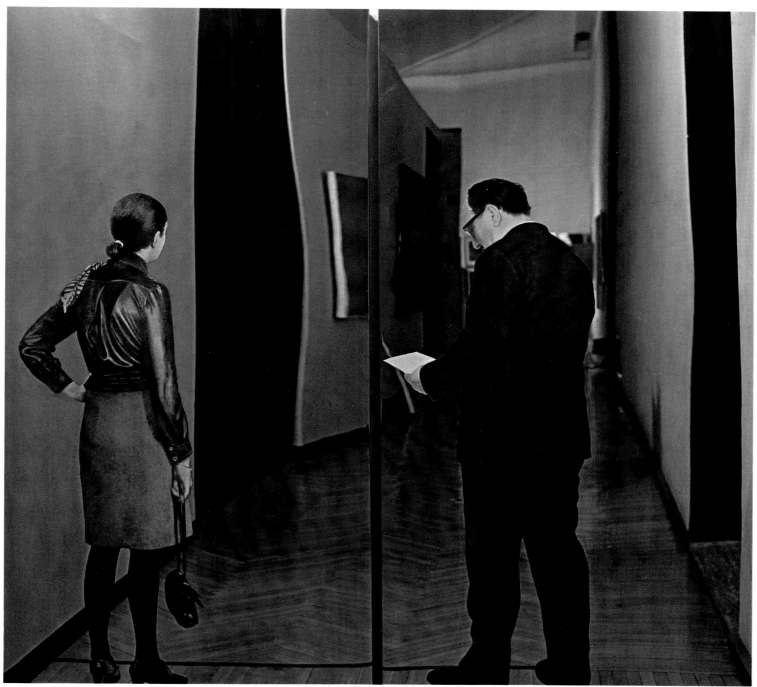

MICHELANGELO PISTOLETTO: *The Visitors*, 1968

Few painters use photographs as the basis for their work quite as literally as Helmmo Kindermann. He enlarges photographs directly onto sensitized canvas for use both as guideline and as inspiration in applying paint. The photographic images he works with are old-fashioned Brownie snapshots. He likes the contrast between their fuzzy, faded naïveté and the bright, slick colors of the acrylic paint he adds to them. He also likes the amateur photographers' direct and uncomplicated approach to their subjects—and in fact when he tried using his own photographs as raw material for paintings, he found them too carefully planned.

Kindermann buys his snapshots in antique shops or borrows them from family photograph albums. (The little boy at the front of the car at far right is the father of one of Kindermann's close friends.) He often has to make a new negative, since the original is generally lost—and frequently in the course of doing so he ages the image still further by bleaching it. The sepia tones in the baby scale picture are partly the product of such artificial aging. To transfer his images onto canvas, Kindermann uses a liquid emulsion available in some photographic supply stores, diluting it with water and applying it in two thin coats so it will soak into the canvas instead of lying on the surface, thus preserving the fabric's texture.

HELMMO KINDERMANN: *Baby Scale,* 1969

The subject of one of Kindermann's beginning excursions into photopainting was a baby looking at his reflection while being weighed on a scale. The picture benefits from an accident. The feathery edge of sepia tone running diagonally from top to bottom is not the product of age but the junction of two different batches of emulsion which were diluted in slightly different proportions.

Except for the passengers' faces and a few stray ▶ car parts, nothing remains of the photographic beginnings of the picture at right, a family group posed by the family auto. The striated edge of color is a transitional device, bridging the shift from photograph to painted abstraction; the little biplane is an afterthought, clipped from the pages of a magazine and pasted on.

HELMMO KINDERMANN: *Roadside Rest*, 1970

Sculptured Shapes from Photographs

The boundaries that once separated photography, painting and sculpture are no longer inviolate; artists in all three media have crossed from one to another to create some of their most imaginative recent work. By challenging the conventional idea that a photograph is a two-dimensional image on a two-dimensional sheet of paper—and no more than that—they have brought pictures out into space.

Some of the first steps in this direction were taken by the sculptor Lucas Samaras, who applied photographs to assemblages like the box at right. When Samaras was a child in Greece during World War II—long before the advent of Pop art—he often put homely oddments together for his own amusement. "I would play with scissors, buttons, pins, spools of thread, things found in boxes, particularly in sewing boxes," he says. "In a sense I still do play with things from around the house." In that respect he resembles the Pop artists of the 1960s, but he departed from their theme—the celebration of the banal and the innocuous—to suggest mysticism and often even a certain sadism, as in this example. Some further ventures into photosculpture appear on the following pages.

A box serves as a three-dimensional frame for photoportraits of sculptor Lucas Samaras. Filled with pins, thread, braided yarn, lenses and a stuffed bird that seems to have alighted from the nearest window, the construction resembles a medieval altar triptych, even to the artist's vague, mystical presence in the box lids. The sharp points of the pins are sticking into the artist's image, and the little bird seems to be pecking at his sideburn—suggestions of pain and cruelty that recur in Samaras' work.

In a relief built up from cutouts, the photosculptor
has made two faces out of one and the Picasso-
like result presents the viewer with eyes that
seem to flutter. The top eye is mounted on a steel
peg, the other images on wood; the whole is
coated with plastic and seems, like the crescent
moon it resembles, to be suspended in space.

A single photograph of a woman's face, printed ▶
three times and shifted in three different ways,
suggests the volatile moods of human personality.
To counteract what the photosculptor sees as
"the main fault of photography—its flatness," he
cut the prints into vertical strips, pasted them on
strips of wood and then slid the slats upward and
downward. The result is a triple distortion of the
original image, providing a quizzical smile at left,
a bland gaze in the center and a pout at right.

JUST JAECKIN: *Moon*, 1971

JUST JAECKIN: *The Three Sisters*, 1971

119

In a construction that measures 25 inches high, 8 inches wide and 3½ inches deep, artist Dale Quarterman has produced a figure possessing not merely three dimensions (height, breadth and depth) but four (including time), for the subject appears in progressive stages of undress. The construction consists of photographs mounted on all sides of a piece of foam plastic.

DALE QUARTERMAN: *Marvella,* 1969

Into the Third Dimension 5

In the laser laboratory at Stanford University, a ▶
research engineer demonstrates an illusion
created by holography. His hand, thrust behind an
illuminated plate bearing a holographic image of
a wine bottle, appears to be grasping the bottle.
But the mirror, placed to reflect him but not
the hologram, reveals that he is empty-handed.

MATT LEHMANN: *Holographic Image*, 1968

The Illusion of Depth

One tantalizing idea that has been on and off the frontier ever since photography was invented is the three-dimensional picture—one that shows its subject in natural depth instead of in an artificially flat two-dimensional representation. Workable techniques for adding the third dimension were first developed more than a century ago, and they enjoyed a great vogue during Victorian times. While most of the early schemes for reproducing the extra dimension required special spectacles or optical devices, they created such an intriguing illusion that they are still widely used, and new methods are arousing even more interest in three-dimensional photography.

Most contemporary three-dimensional work is still being done with a system conceived at almost exactly the same time the first photographs amazed the world. In 1838, the year before the daguerreotype was unveiled, the English scientist Sir Charles Wheatstone, renowned for his work on electrical circuitry and on telegraphy, proposed a viewer outfitted with mirrors that would enable geometric drawings to be seen in three dimensions. Sir Charles, who named his invention the stereoscope from the Greek *stereos,* for "solid," and *skopein,* "to see," to indicate "its property of representing solid figures," realized quickly its potential for photography. He got his friend William Henry Fox Talbot, the country gentleman who invented the calotype, precursor of the modern negative-positive system of photography, to make pairs of photographs for the stereoscope.

The process they introduced to the world provides the third dimension in roughly the same way that the human optical system does. Man has binocular vision: each eye sees an image that is slightly different from the other. This pair of images is merged in the brain to create the sensation of depth. The stereoscopic camera, to furnish the two images the brain requires for depth perception, has two lenses placed about two-and-a-half inches apart, roughly the distance between the pupils of the eyes. The twin pictures the camera produces must be viewed through a stereoscope, which makes sure the right-hand picture reaches the right eye, the left-hand picture the left eye, thus tricking the brain into fusing two flat images into a rounded one.

Stereoscopic photographs caused a stir when exhibited in 1841 at the Royal Academy of Science in Brussels, but they might have remained obscure oddities had they not been blessed by the reigning monarch of the age, Queen Victoria of England. At the world's fair in London's Crystal Palace in 1851, Queen Victoria fell under the spell of the stereoscopes she saw on display. The French exhibitors, Duboscq & Soleil, promptly presented Her Majesty with one. Suddenly the stereoscope was given the royal seal of approval and the public responded eagerly.

Gazing into stereoscopes soon became the rage. No parlor on either side of the Atlantic could be considered up to date without a viewer and its ac-

companying basket full of stereoscopic pictures. Photographers reacted quickly to the booming market for stereo pictures by scurrying to the ends of the earth lugging their heavy double-lensed cameras. No human event was too monumental—or too insignificant—and no natural wonder was too inaccessible for the stereoscopic photographers. They recorded the triumphs and horrors of the American Civil War, made stately portraits of ocean-going yachts under sail, captured the frustrations of New York City's horse-and-buggy traffic jams, recorded treacly scenes of domesticity, and even injected drama into a scenic attraction by taking stereo pictures of a performer walking a tightrope over Niagara Falls.

The infatuation with the stereoscopic method has lingered to this day. Stereoscopic equipment has been refined and sophisticated to such a degree that the astronauts who explore the moon take stereoscopic pictures of what they see. For earthly uses, modern stereo cameras are conveniently small—and even ordinary cameras can be fitted with adapters to make stereo pictures. Among other subjects they can take close-ups of insects or blossoms, from as near as four inches, to produce transparencies for viewing through a stereoscope or projecting on a screen.

The quest for the third dimension has led researchers down a number of paths besides stereoscopy—most of them dead ends. Up to now, only one system re-creates truly lifelike images in three dimensions without the necessity of the bothersome viewers or glasses. This process, called holography *(page 134),* someday may graft the third dimension permanently onto the body of photography. ☐

Stereopticons Old and New

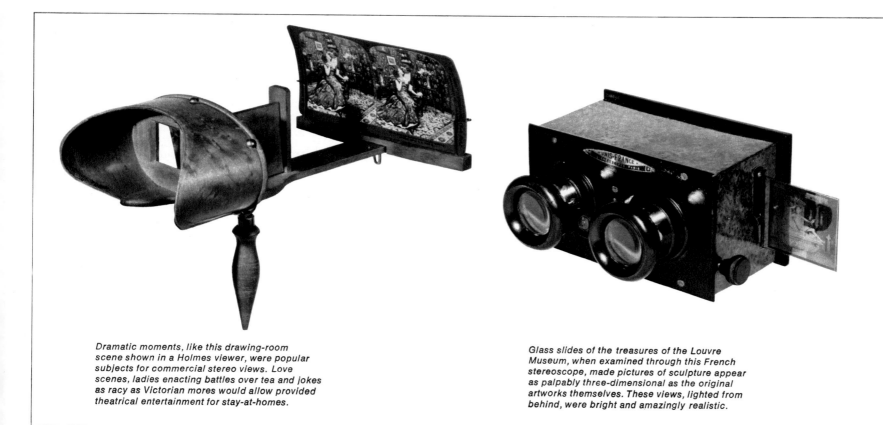

Dramatic moments, like this drawing-room scene shown in a Holmes viewer, were popular subjects for commercial stereo views. Love scenes, ladies enacting battles over tea and jokes as racy as Victorian mores would allow provided theatrical entertainment for stay-at-homes.

Glass slides of the treasures of the Louvre Museum, when examined through this French stereoscope, made pictures of sculpture appear as palpably three-dimensional as the original artworks themselves. These views, lighted from behind, were bright and amazingly realistic.

If an ordinary picture is worth a thousand words, then one in three dimensions must have been worth a million to the Victorians, judging from the volumes of praise written about stereoscopy during the 1850s. This method of making and viewing pictures in depth was then scarcely a decade old, but its popularity had leaped the Atlantic from Europe to America and it had become the television of the day on both shores.

Unmatched in vividness by any other recording medium, stereo views became indispensable to a news-hungry world. Photographic companies in every city struggled to meet the public's insatiable demand. By 1862, the major distributors could boast annual sales of over a million views. Oliver Wendell Holmes, the noted physician-author, who was also a talented amateur photographer, estimated he had examined 100,000 stereographs, and rhapsodized in the *Atlantic Monthly* that, with the aid of a stereoscope, "I . . . leave my outward frame in the armchair at my table, while in spirit I am looking down upon Jerusalem from the Mount of Olives."

Holmes did not confine his enthusiasm to words, and in 1861 he invented a form of the stereoscope *(above left)* that was lighter, cheaper and easier to operate than the numerous versions that preceded it.

Holmes's viewer, like most others of the 19th Century, was designed to hold a cardboard on which two pictures were mounted side by side, each showing the same subject from a slightly different viewpoint. The mechanism was simple: a wooden shaft about 10 inches long, with clips to stand the picture

This 1874 travel book did more than even the most lavishly illustrated coffee-table book of today, for it offered pictures in three dimensions. Its 22 pages of stereoscopic views of New Hampshire's White Mountains came to life when examined through a pair of glass lenses inserted like windows into the book's hinged front cover.

A present-day stereo viewer operates on the same principles as its century-old predecessors, but in place of paper prints or glass slides, it accommodates discs containing seven pairs of miniature transparencies—in vivid color.

card at one end and at the other end two lenses mounted in a board enclosed by a hood. The person using it peered through the lenses, which conveyed the right-hand picture to his right eye, and the left-hand one to his left. A vertical strip placed between the lenses along the shaft kept his eyes from wandering, while the hood rested on his forehead to steady the device and eliminate distractions. When he gazed straight ahead through the lenses, as though looking far into the distance at the real scene, the two images merged

into one so vivid he might have thought he could step right into the picture.

Holmes's stereo viewer became the most widely used type in America. But in Europe, other designs were as popular. In France, for instance, viewers were made with slots to accommodate glass slides instead of prints on cardboard. The principle on which they operated was the same, although the viewer was a closed box *(above, second from left)* rather than an open skeleton, and the transparent picture was evenly illuminated from behind by light

entering through a ground-glass screen that was built into the back of the box.

While stereoscopic viewing enjoyed its greatest vogue—and underwent the widest range of modifications—over a century ago when it was relatively new, the public has never abandoned it altogether. Both viewers and views continue to be made. Although the modern viewer shown above at right was "invented" in 1938, just 100 years after the original version, it works on the same principle of binocular vision, with two lenses and pictures in pairs.

Cameras and Projectors for Stereo

While most stereo pictures are made with special equipment like that shown at the tops of these pages, all that is needed to create the effect of depth is a way of getting two photographs of the same subject taken from slightly different viewpoints. The most rudimentary technique uses an ordinary camera to shoot two pictures in succession; between exposures the camera is moved sideways 2½ inches (the average distance between the centers of a person's two eyes) and the resultant prints are looked at through a viewer. In taking the pictures the proper separation is easily obtained with the "hip method": standing with legs slightly apart and weight all on one leg, take the first shot; then transfer the weight to the other leg for the second. The shift in body weight causes torso and head —and camera—to move sideways the requisite 2½ inches. American astronauts on the Apollo mission found that this simple one-camera, weight-shifting method could yield satisfactory stereoscopic pictures of lunar landscapes.

These techniques can be successful only when the subject is motionless, however; for if it has moved even the slightest bit between exposures, the results in the viewer will not mesh but instead will give a hopeless blur. Two identical cameras lashed together and fitted with a cable release that triggers them both at once offer one solution to this problem. But a better solution is a two-eyed camera, one built with two identical lenses and shutters, to take two exposures simultaneously. That is exactly what a stereo camera is.

In the 19th Century, when photography was new and stereo one of the most popular forms of the art, nearly every photographer used a stereo as well as an ordinary camera. But other fads edged stereo out of the limelight. Today, it is mainly the province of a small but worldwide community of 3-D buffs linked by clubs and journals. But there are enough members in this fraternity to warrant the manufacture—and the steady updating—of stereo cameras, such as the one shown above. They consist of two cameras in one body, sharing a common film plane. Most use ordinary 35mm film, color or black-and-white, and are as easy to use as any other camera.

For the photographer who wants to

A modern 35mm stereo camera (above) has two lenses to make a pair of pictures at each exposure. The viewfinder is between the two lenses, with the shutter-cocking lever below it. The focusing knob is on the right side of the body; a flip-up lens cap is hinged to the front. On a 36-exposure roll it makes 28 pairs of slides that, when mounted, can be shown in the double-lens, polarizer-equipped stereo projector below. Polarizing spectacles are worn for viewing.

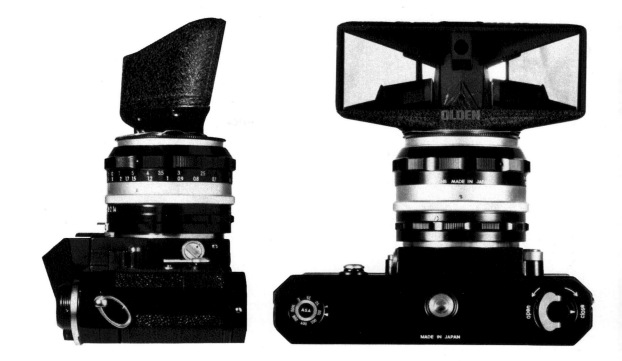

A prism attachment, containing a complex of mirrors and a glass prism, can be used, with the addition of an adapter-ring, to convert any 35mm SLR into a stereo camera. When the camera is in the normal shooting position, the prism faces downward, so for stereo picture-taking the camera must be pointed straight up—in the view at right, above, it is shooting at the reader. The same converter, along with a polarizer, attaches to a slide projector (below) for stereo shows.

capture the depth dimension only part of the time, camera manufacturers now make stereo converters that can be fitted to almost any 35mm camera. One is a simple triangular attachment *(above, right)* consisting of a pair of mirrors and a prism. The mirrors pick up the subject from two different angles and relay the images to the prism, which sends them through the lens to the film. The result is a single frame containing a stereo pair of pictures.

Hand viewers offer a satisfactory, if solitary, way of looking at pictures taken with this attachment or with a stereo camera. But for a more sociable kind of viewing the pictures can be projected. The converter can be attached to an ordinary slide projector as at left, and special double-lens projectors like the one at far left, below, show the pairs made by a stereo camera. Both types have attachments to polarize one image of the pair one way, the other image the other way. Matching polarizing eyeglasses permit one eye to see only one image, the other eye only the other image. The brain then takes over and fuses these two pictures into a single three-dimensional scene.

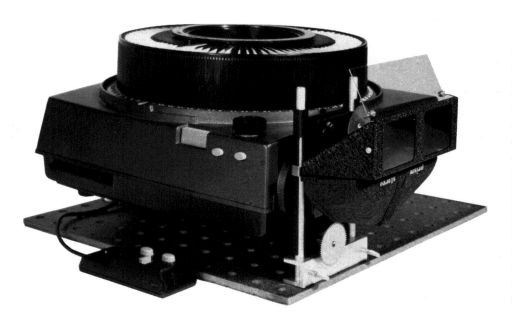

129

Two Ways to Print 3-D

A major part of 20th Century research in stereoscopic viewing has been devoted to finding ways of imparting a three-dimensional effect with a single picture. The problem—and by now scientists have arrived at several solutions to it—is to make one picture that actually contains two views, and then to devise viewing materials or systems that can combine this double image into one seen in the round.

In the oldest and simplest version of single-picture stereo, called the anaglyph, two views of a subject taken with a stereo camera are printed in contrasting colors (say, red and green) onto a single sheet, not superimposed exactly but slightly out of line. To the unaided eye the result seems a blurry jumble; but when the observer dons a pair of special eyeglasses having one lens tinted red, the other green, the two images align into a 3-D picture. The red lens blocks out the red picture and the green lens blocks out the green picture. Thus each eye sees only one image —as in all stereo viewing—and the two fuse to give the sense of depth.

One adaptation of the anaglyph principle is called a vectograph *(opposite),* which uses polarizing sheets instead of color to separate the two images. One of the images is printed on the front and the other on the back of a transparent surface coated with polarizing material. The function of the polarization is to organize all the light rays so that rays from one image vibrate in one direction, while those from the other vibrate at right angles. The viewing spectacles have lenses polarized at corresponding angles, making a stereoscopic view by bringing one image to the right eye, the other to the left.

Other research has gone into inventing stereoscopic techniques that require no viewing aids at all. One such stereo picture, technically described as a parallax panoramagram but trade-named the Xograph *(diagram, right),* is based on a single photograph. The picture is made with a vertically slit lens that causes the subject to register on the film as a series of parallel strips. To sort out the fuzzy, striated image that results, the picture is laminated with a plastic having tiny strip lenses embossed on it. When the picture is seen through these lenses, half of its strips are visible to the viewer's right eye, and the remaining half are visible to the left. This results in separating the picture into the two distinct images needed for stereoscopic seeing.

The parallax panoramagram technique for suggesting depth in a single picture is diagramed in cross section below. The image is broken into strips, over which are laid clear plastic half-cylinders (shown in profile), 112 to the inch, to act as lenses. Through them, the viewer sees parts of the picture (light gray bars) with his right eye and other parts (black bars) with his left eye.

right eye left eye

seen by left eye seen by right eye

The blurred-looking picture at right of a 15-times-life-sized housefly is a vectograph (diagram below), one of many used by ophthalmologists to test binocular vision. If the patient reacts when shown the lifelike vectograph, his eyes are working properly to bring the image into vivid 3-D.

A vectograph stereo picture contains two overlapping images that are polarized by layers of submicroscopic crystals. The polarization gives light passing through each picture a definite direction, like wood grain (diagonal lines). When the picture is seen with polarizing spectacles whose lenses each match the grain of one image, the right eye sees the rear image (a), the left eye the front one (b), creating a 3-D effect.

left eye right eye

L HOUSE FLY R
POLAROID 3-D VECTOGRAPH

Into the Third Dimension
The 360-Degree View

EUGENE TRACHTMAN: *View of New York Harbor,* 1957

Almost everyone who has attended a world's fair in recent years has experienced the sensation of seeing a three-dimensional view that is created when a 360° picture is projected on a circular screen. Such an all-encompassing scene creates a vivid sensation of adventure, whether the picture represents outer space or a cityscape.

Among several schemes for creating such all-around scenes is one devised by Dr. Eugene Trachtman, who has devoted nearly 20 years to perfecting it. He first made pictures like the New York vista above—a flattened-out version of the scene a tourist might see standing atop a tall building and turning around in a full circle.

To make this photograph, Trachtman modified a 35mm camera, replacing the original shutter with a narrow slit that remains stationary while the film moves behind it. To move the film, the regular advance mechanism was rigged to a battery-driven motor; the whole camera was mounted to pivot on a steel platform, and the same motor rotated the camera while it advanced the film.

Trachtman's first effort was really a modification of the "panorama" camera that is still used to photograph large groups of people. Once his camera was perfected, he returned to his workshop and surfaced a few months later with a projection system that converted his strip photograph into a huge walk-in picture. To achieve this result, he took a 360° photograph, cut it very carefully

into 11 segments and mounted each one. He then arranged 11 projectors to project the segments outward from the exact center of a circular screen. To avoid seams between adjacent images, he altered the slide-holder in each projector so the images had slightly vignetted edges that could overlap.

Trachtman's system was first used in 1969 for a display at the Boston Museum of Fine Arts honoring that institution's centennial. In a gallery with a 130-foot circular screen, Trachtman set his projectors on a platform suspended 20 feet above the floor—high enough to clear the doorways and the heads of spectators and show a sequence of 50 different 360° views of Boston's historic Back Bay area.

Taken with a rotating 35mm camera from atop
a building in downtown Manhattan, the panorama
above conveys the sense of being on an island
by including in one frame views to the north, east,
south and west. The same piers appear at both
ends of the strip because the film was exposed for
slightly more than one revolution of the camera.

Visitors at the Boston Museum of Fine Arts see a
360° view of a Back Bay street as they stand
below a platform from which it is projected onto a
circular screen. To make this picture of the
display in use, a museum photographer used a
fisheye lens while lying on his back on the gallery
floor and pointing his camera toward the ceiling.

TED DULLY: *Projection in the Round*, 1969

133

Holography: A Vision in the Round

The semiannual meetings of the Optical Society of America are seldom note-
worthy for unrestrained excitement, and the 800 or so scientists who gath-
ered in the rambling old Sheraton-Park Hotel in Washington for the April
1964 session expected nothing out of the ordinary. Even the title of one of the
scheduled papers, "Wave Front Reconstruction with Diffused Illumination of
Three-Dimensional Objects," by Emmett N. Leith and Juris Upatnieks of the
University of Michigan, was no tip-off. But when the two young scientists set
up a display of their work, they caused a sensation. The furor they gener-
ated, in Leith's words, was "unbelievable." Hundreds of industry represen-
tatives and academicians waited in line in the hotel corridor to get a look at a
three-dimensional image of a toy train, the most realistic and easiest to see
image ever created by any photographic process. Most of the guests at the
meeting had never seen a hologram in their lives, and they kept asking
"Where is the train?" They could not believe it was a picture and many
looked for trickery—mirrors that might be reflecting a view of an actual toy
hidden in the room.

The scientists' excitement can be understood by anyone who has seen ho-
lograms (they are now frequently displayed, usually at such events as sci-
ence fairs or industrial exhibits). They have to be seen, however, to be truly
appreciated, for their depth cannot be reproduced when they are printed in
books or magazines. The image generated by a hologram is so lifelike that
only its texture, which may be marked by speckles, provides the clue that it is
not the subject itself. Viewers of holograms invariably are tempted to reach
out to seize the image, certain that what they are seeing is an actual, solid
object. They are left empty-handed.

The reason for this uncanny sense of reality is the completeness of the
image. It exists in three dimensions, an optical re-creation of the subject. As
such, it can provide an almost infinite number of distinct views of that sub-
ject. As the observer moves his head, his viewpoint changes and he can see
around the sides. It is as though he were looking out a window at a bird on
the sill: by shifting his angle of view he is able to see its wings and tail as well
as its head. In one demonstration hologram, a boulder seems to be the only
subject shown. Yet if the viewer turns his head a little to look around the
rock, the figure of a man is visible pushing the boulder from behind. In an-
other trick that demonstrates this unique quality of holography, a magnifying
glass enlarges part of the subject *(pages 150-151)*. But as the viewer moves
his head, the area being magnified changes, just as if the glass and subject
were actually there.

Because each hologram contains within it so many views of the subject
waiting to be seen, another remarkable characteristic results. It is possible
to see most of the image by looking at only a portion of the hologram. If the

viewer looks at a small portion of a regular photograph, he sees only what is in that part of the print. In a hologram, all the visual information is spread across the entire picture. Thus, if he looks at only a portion of a hologram, he gains enough information to see most of the image. It is as though he were looking at it directly through a peephole.

Since most holograms must be viewed in darkened rooms to be appreciated, their effect is doubly impressive—and sometimes chilling. To a viewer who is standing in a dimly lit chamber, the holographic portrait of a man, for example, has all the stark reality of a living, breathing person, yet the substance of a photograph and the aura of a ghost. The viewer may forget that he is watching a photographic marvel and, with a shiver of recognition, think he is attending a bizarre wake in which the body has been propped up to be seen through a doorway. At that particular moment, holography may seem a breathtaking—and eerie—exercise in necromancy.

Seeing holography on display immediately sets the mind racing ahead to a day when every house might have the modern equivalent of the ancestral hall, a viewing room where family members, relatives and friends materialize in replica whenever the appropriate hologram is illuminated. The family album could also be full of holograms, informal views that would appear in three dimensions when a light was beamed on them. Instead of the usual flat, two-dimensional pictures on the walls, there might be holograms—studies of people, statues or landscapes—ready to spring into three-dimensional reality when a light is turned on them. It is even conceivable that there might someday be three-dimensional television or realistic home movies in depth. The applications of holography never fail to stimulate speculation and excite wonder among those who first glimpse it.

An air of mystery hangs over holography because of both the haunting images it can produce and the complex laws of optics on which it is based. By comparison, ordinary photography is downright simple. The regular camera uses a lens system to pick up light waves that are reflected off a subject. It focuses these waves as an image, recording only the brightness and darkness of the reflected light waves. The most important aspects of depth—the third dimension—are not registered because they are carried in the *phase* of the light waves, the order in which one train of waves follows another, and this characteristic is not recorded. Therefore, the image produced by the ordinary camera is two dimensional and seems flat.

Holography takes photography into the third dimension. It catches on film the phase that conveys the depth information, as well as the varying intensities of the light waves that create the lightness and darkness on the ordinary film in a camera. Moreover, holography records all this visual

information without lenses. In effect, it does not merely record images—it reproduces them exactly.

Holography was the brain child of Dennis Gabor *(pages 146-147),* a Hungarian engineer who, after years of pondering, worked out its fundamental principles at Eastertime 1947, and a quarter-century later, in 1971, was awarded the Nobel Prize in physics for his brilliant invention. Gabor made a few experimental holograms that amazed his colleagues, published a paper on his work, tried to drum up some commercial interest in it with little success, and then did not return to holography for a number of years. He named the exposed film plate of his process a hologram from the Greek words *holos,* "whole," and *gramma,* "message." The hologram thus contained the whole message and the process was termed holography. (These terms are often incorrectly linked with the word holograph, which means a document in the handwriting of the author.)

Gabor's first holograms seemed like little more than laboratory curiosities. Theoretically they should have reproduced three-dimensional images, but in practice they worked well only for two-dimensional ones. The fault lay mainly with the light source. The best then available—a mercury arc lamp —could not produce waves pure enough in color and orderly enough in phase to record and reproduce sharp images of three-dimensional objects. In 1960 the ultimate solution to this problem became available with the invention of the laser, the electronic light source that emits a concentrated beam of absolutely pure color and in perfectly orderly phase. Its waves travel in lockstep, like a drill team on parade, moving in phase with one another and going along precisely parallel lines. This type of disciplined light is called coherent, and can be produced only by a laser. The white light that radiates from the sun or an ordinary light bulb contains the whole spectrum of colors and a variety of frequencies and phases. This mix of colors and phases causes white light to be called incoherent, and even seemingly pure-color lights, like a mercury arc, are partially incoherent.

Among the first to apply the laser's coherent light to holography were Leith and Upatnieks. They worked out the technique that is now generally used for holography, and eliminated the ghost images that had plagued Gabor's early works. Today's holograms are usually made in a darkened studio, the room itself acting as the camera. A laser beam is split in two, one half traveling to the subject and the other half, which is called the reference beam, directed by mirrors to the film. The laser light that reflects off the subject also travels to the film, but its waves are no longer orderly. Hitting the subject causes them to rebound at various angles so that they get out of step. When these disturbed waves meet the regimented waves from the reference beam, an in-

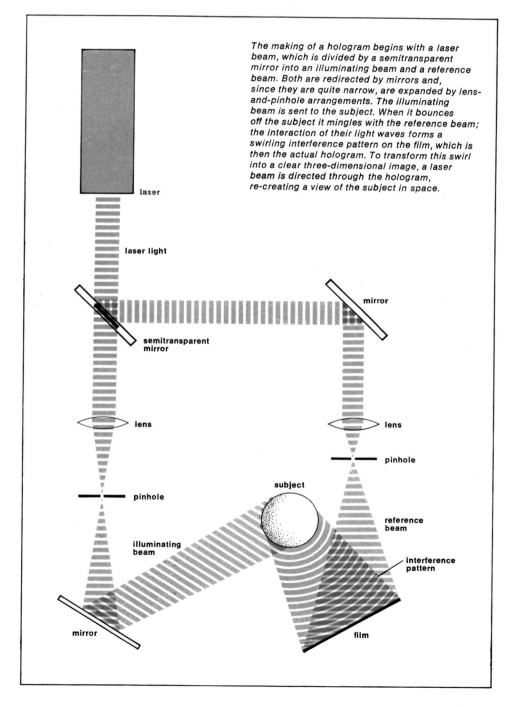

laser

laser light

mirror

semitransparent
mirror

lens

lens

pinhole

pinhole

subject

illuminating
beam

reference
beam

interference
pattern

mirror

film

The making of a hologram begins with a laser beam, which is divided by a semitransparent mirror into an illuminating beam and a reference beam. Both are redirected by mirrors and, since they are quite narrow, are expanded by lens-and-pinhole arrangements. The illuminating beam is sent to the subject. When it bounces off the subject it mingles with the reference beam; the interaction of their light waves forms a swirling interference pattern on the film, which is then the actual hologram. To transform this swirl into a clear three-dimensional image, a laser beam is directed through the hologram, re-creating a view of the subject in space.

This multiple-exposure photograph shows parts of what a viewer sees as he moves his head in front of a hologram that reveals all sides of a doll. To prepare the all-around hologram, the doll was rotated a little at a time while about a hundred holograms were made of it. These holograms were then assembled in a row, to represent a 360° rotation of the doll. A master hologram was next made, combining all these views in one. To simulate its walk-around, three-dimensional effect for purposes of this two-dimensional photograph, exposures were made at five different positions with a camera that was panning across the master hologram.

teraction occurs. The light waves clash, canceling one another in some places, reinforcing one another in other places. The result of this clashing of light waves is recorded in the emulsion of the film as a strange design called an interference pattern.

When the film is developed, no recognizable picture is discernible. Instead, the plate looks as if it contains only a large smudge or fingerprint. Studied under a microscope, this smudge is seen to be made up of light and dark bands. The different tones of the bands indicate the different light-wave intensities. The spaces between the bands indicate the variations in phase. These smudges are thus a record of all the visual information contained in the light waves that have reflected off the subject. The information, like the tone in a tuning fork, is entrapped, just waiting to be released.

One way to free this information is to shine a laser beam through the hologram. As the coherent waves of the laser strike the interference pattern on the film they are bent and altered, changing their intensity and phase to match those of the light waves that created the hologram. The light waves that emerge are duplicates of the light waves that originally came from the subject. The hologram thus creates an exact image of the subject by producing light waves that are replicas of those the subject has reflected. The

viewer sees the image in three dimensions and in life size at the same distance the subject had been from the film when the hologram was made. The method has actually reconstructed an image of the subject from light waves.

This method requires a laser beam both for recording the image and for projecting it. But in 1965 need for the expensive and cumbersome viewing laser was eliminated with the perfection of the reflecting hologram. It is made in the usual way, with a split laser beam, but its three-dimensional image can be seen simply by shining an ordinary white light, such as a lamp or flashlight, on it *(page 158)*.

Work on the reflecting hologram was initiated by a Russian scientist, Y. N. Denisyuk. But the method was perfected by George Stroke, the American who had been an early leader in the field of holography at the University of Michigan, and who is now at the State University of New York at Stony Brook. To make the reflecting hologram, Stroke simply altered the angle of the reference beam, the light source that does not go to the subject. Instead of hitting the front of the photographic plate, it is directed by mirrors to the rear of the film. The coherent light waves of the reference beam then mix with the incoherent waves from the subject deep in the emulsion of the film, where the interference pattern is formed. When a beam of ordinary white light is reflected off the developed film, these deep-seated layers filter out all of the components except those of the laser beam used to illuminate the subject. Only these waves are reflected back to the viewer as a three-dimensional image. This significant breakthrough widened holography's field of uses and established it firmly in the photographic marketplace. The reflecting hologram made it possible to show the process without elaborate equipment.

While the reflecting hologram opened up the process for popular use, industry was exploring applications that had nothing to do with holography's ability to create a three-dimensional image. One of the greatest values of the process is its capacity to store and retrieve great amounts of information quickly and easily. Each hologram contains many views of its subject, and each of these is a unique record of information. In addition, early experimenters in holography were startled—and pleased—to learn that a number of different images can be placed on a single film by holography just by changing the angle at which the laser beam hits, or by altering the wavelength of the beam. In turn, each of these two-dimensional pictures can then be brought into view by shifting the viewing beam in a corresponding fashion. As techniques became more sophisticated, a thicker emulsion was produced, which permitted even more images to be stored in one film. Also, many small pictures can be reduced to tiny dots or squares that can be placed side by side on a single plane of the holographic film. Each of these

tiny holograms may store either images, such as two-dimensional pictures of pages of text, or numerical data in the form of coded light and dark dots. In one dramatic example of this capacity, it is estimated that holograms able to reproduce every word in the *Encyclopaedia Britannica* could be fitted onto a film the size of a credit card. Further research involving special crystals, which are only the size of sugar cubes, has improved this system literally a thousandfold. Through a complicated holographic process that employs a laser to embed atomic patterns in a cube *(pages 156-157),* all the information in a thousand 24-volume sets of this same *Encyclopaedia Britannica* could be contained in one of these tiny cubes.

Holography has also won wide acceptance in the industrial world as a rapid and efficient means of testing goods and materials without destroying them *(page 154).* Because a hologram records the phase of light waves—a characteristic abruptly altered by any movement of the subject—it can be employed to ferret out deformation, stress or vibrations in such industrial products as rubber tires or the fuselage skins of airplanes. The testing system relies on a double-exposure hologram. First, a hologram of the subject is made under normal conditions; then a second hologram is exposed on the same film during testing conditions—temperatures or stress that could cause buckling of metal or separation of the plies of a tire. The two holograms are then superimposed. If there has been no change in the subject between the normal and testing states, the hologram patterns will mesh, indicating that the material has not been altered by the test. But if portions of the material have shown even slight signs of giving way by a change in the surface, the hologram patterns will interact at the point of stress. The wavy lines of the patterns will not mesh and whorls or blacked-out sections will betray where changes have taken place.

Even more remarkable is holography's ability to portray things that do not even exist: a visual model created mathematically. Such legerdemain requires a computer that can be programed to convert numerical data into tracings of curves and drawings. To synthesize a hologram, data on the imagined object and its influence on light waves are used by the computer to calculate the phases of waves the object would reflect (if it existed); these phases are printed out not as numbers but as a black-and-white pattern—a hologram. The printed hologram is then simply converted into a transparency; when it is projected with a laser, a three-dimensional image of the imaginary object is created. Suppose an architect or planner wants to see how a proposed building will look in its setting after it is completed. Information from the plans is fed into a computer, which transcribes it into a black-and-white pattern. This computer-made printout is then photographed

and a transparency made. The transparency, illuminated by a laser beam, presents a three-dimensional image of the building and its surroundings.

Industry and medical science are also exploring acoustical holography, a process that depends on sound rather than light waves. Seeing by sound is now common—the system called sonar produces radarlike images of objects underwater by sending out sound waves, picking up the echoes and converting them into pictures on a scope. Acoustical holography works exactly like regular holography, except that instead of using light waves it works with sound waves, usually ultrasonic—too high-pitched to be audible. And the subject is usually submerged in water, since that medium carries sound waves better than air.

There are two methods of making acoustical holograms. In one, an ultrasonic signal is bounced off the object, and the reflections are received by a special mechanism that combines them with a reference signal. The waves from the object mix with those of the reference signal, creating a sound interference pattern, which is converted into a light pattern. Then this visual pattern is recorded on a photographic transparency that acts as a hologram. Shining a laser beam through the transparency produces a visible image of the object, just as it would with any hologram.

In the second method, called liquid-surface holography, the object in the water also has sound bounced off it. The reference signal is directed toward the surface of the liquid, where it meets with the reflected (or transmitted) sound waves. The surface thus becomes the place where the sound waves mix to form the interference pattern. It may then be photographed for reconstruction as a hologram, or the surface patterns can be picked up by a device like a TV camera as electronic signals for viewing on a display screen. An acoustical hologram, like the optical hologram, records images in three dimensions—the recording is simply a pattern of ripples on a liquid surface instead of a pattern of light densities that are captured in the emulsion of the photographic film.

Acoustical holography has been tested for use in underwater detection —some believe that it could replace sonar for locating submarines. Like sonar, it may also be used for exploring and mapping the bottom of the ocean floor, for rescue operations and as a navigational aid. In addition, this type of holography has proved effective for nondestructive testing. Through the use of acoustical holography tiny flaws have been detected that were as deep as eight inches below the surface of steel and aluminum blocks.

Acoustical holography also promises to provide physicians better—and safer—pictures of the inside of the body than traditional X-rays. For this purpose, the body is immersed in water and an ultrasonic signal is directed toward the organ, bone or vessel to be viewed. The waves penetrate the body,

which is largely water itself, but are reflected in varying degrees by internal structures to generate a liquid-surface hologram. The method can make visible glands, tumors, blood vessels and other soft tissue that often cannot be seen in an X-ray. The process is particularly useful for the study of breast tumors and muscle damage because it avoids the danger of X-ray radiation.

Because of the immense commercial possibilities, there has been much speculation about the use of holography for three-dimensional motion pictures and television. Before that is possible, however, some technical breakthroughs will have to be made—particularly for TV. One problem is the low light level of the lasers that must illuminate a scene for holography. They concentrate their beams so narrowly that they restrict the field of action to the area of a room about 10 feet square, a small space in which to shoot a movie. Not only that, but the beams pose a hazard to the actors. The energy is so concentrated it can burn a hole in the retina of the eye, causing blindness. Prolonged direct exposure can also damage the skin. One possible solution is the use of ground-glass screens to diffuse the rays and direct them away from the face, a technique now used in making holographic portraits. But diffusing and redirecting laser beams from a roomful of busy actors is still a tricky and hazardous business.

One means of obtaining three-dimensional movies has been proposed by Dr. Gabor. In his system, which combines holography with the stereoscope *(pages 126-129),* a large curved screen is coated with a material that makes it act like a neutral holographic filter capable of reflecting one kind of image to the right, another to the left. To gain a stereoscopic effect, two motion picture projectors show conventional film by the light of laser beams; one projector shows an image that is picked up by the viewer's right eye, the other shows one that is picked up by the left eye—the combination creating the three-dimensional effect of the stereoscope. Since the movies projected are made with conventional lighting equipment, the dangers and limitations of laser light are avoided.

Whether this method would be successful in actual practice has yet to be determined. Its chances do appear promising, but the prospects of three-dimensional television through holography seem bleak. The hologram creates three-dimensional images because it is able to convey so much visual information. To transmit all the information required to produce a holographic image on television, however, upward of a thousand channels might be needed. Even in this age of technology this seems a hopeless task. And even if all these channels were possible, entertainers on three-dimensional television equipped with today's small flat screens would resemble tiny puppets. Much larger screens would be needed to gain the proper effect.

The blurred picture of a microscope at right was transformed into a recognizable view (far right) by a special use of holography. First, two transparencies are made with laser light—one of the entire blurred photograph of the microscope, the other of one of its spots of light (any spot will do so long as it is in the photograph). Then a hologram of the blurred spot is made. Laser light is next beamed through the transparency of the entire blurred microscope photograph and also through a clarifying filter, a sandwich made up of the hologram and the blurred-spot transparency from which the hologram was made. This filter becomes a sort of physical pattern of the optical process that caused the point to be blurred; it reverses the process, turning each of the blurred spots in the whole picture into sharper points. Thus the filtered image of the microscope is clearer than the original.

Holography still may turn up on the home TV screen, however, not to provide three-dimensional pictures but to make a new kind of tape cartridge —of shows, plays, operas or sporting events that viewers can select and play on their own sets. This TV playback system, called SelectaVision, transforms a standard movie or video tape into a special color-encoded film, which is converted by split laser beams to a series of holograms that are embossed on a strip rather than recorded photographically. The embossed holograms can be duplicated by mass-production methods, rather like phonograph records, to make low-cost copies on plastic tape. For playback on the home TV set, the tape passes between a small low-powered laser and a small TV camera. They reconstruct the hologram patterns into visible color images and convert them to TV signals for display on the screen. The picture seen from this tape is two dimensional. Holography has been used only to record information. In this case, it is solely a means of transmitting video signals on inexpensive tape, not a method of creating three-dimensional images.

For the still photographer, holography may offer a way to restore pictures that are hopelessly blurred. A new deblurring technique, developed by George Stroke at Stony Brook, turns every blurred point in a picture into a sharp point. The process works because each blurred point contains all the optical information of a sharp point; the information is simply spread in a way that can be expressed as a series of mathematical equations. The blurring can be cleared by a filter that changes light waves according to the

same mathematical equations applied in reverse. Such a filter is made, Stroke's mathematical studies showed, by making a transparency from a single blurred point, converting it into a hologram and then combining the two. When a laser beam is sent through a transparency of the original blurred picture and the deblurring filter, a clearer image of the original subject appears. The technique has been used to clarify blurred pictures of the earth and the moon taken on space missions.

Stroke developed the technique to improve the resolution of the electron microscope. So successful was his work that by filtering blurred, illegible electron micrographs through a hologram, he produced in 1971 clear pictures of a virus resembling the double-helix structure of the DNA molecule. When this process is applied to everyday photography, a great many seemingly lost pictures can be reclaimed.

Most of the fascinating applications of holography remain tantalizingly distant, for holograms are still very difficult to make. Lasers are always involved and they are dangerous and expensive devices. There are two types of lasers —steady state, which provides a continuous beam of light, and pulsed, which emits flashes. The steady-state laser is less expensive—a small one for a home laboratory could be bought for about $100; a larger one for professional use costs about $6,000. The problem with the steady-state laser for holography is its low level of light output, which demands long exposure times. In addition, the film used for holograms must have a very fine grain to record every bit of information, and fine-grain films are slow, lengthening exposure times still further. As a result, any movement during picture taking ruins the hologram. A shift of less than one millionth of an inch can cause blurring or blacking out of parts of the view—helpful in holographic testing of materials but anathema to picturemakers. Steady-state photographs have been made only in the laboratory; to take a sharp picture, the subject must be set on a massive stone slab bench that weighs about eight tons and is supported on vibration-damping air bags. No talking is permitted during exposure since even voice vibrations can adversely affect the hologram. Even then, exposures must sometimes be made in the small hours of the night when activity in the laboratory building is minimal. All these precautions naturally limit holography's range and applicability.

The development of the more powerful pulsed laser eliminated the exposure problem—pulsed lasers can make holograms in a few billionths of a second exposure time. They also produce so much more light than the steady-state lasers that they could be used for making casual snapshots (once the dangers of the beam were blunted). But the pulsed laser is an extremely expensive piece of equipment, costing $40,000 and up. It is also a

large, hard-to-move mechanism that tends to eliminate any mobility on the part of the photographer. Even so, pulsed lasers could be mounted on trailers and carted to sites of interest where holograms could then be made. Enthusiasts for the medium suggest that mobile hologram-producing units could travel to important archeological sites to make holograms of significant areas of ruins and pieces of art discovered there. They could also travel to the major museums to make holograms of the most interesting art objects: sculptures, artifacts and carvings. All these images could be mass reproduced as reflecting holograms and sent to schools, universities, libraries and exhibition halls in a perfect wedding of technology and education.

Where then is holography? Many experts feel it is where traditional photography was in the mid-19th Century: its functions are understood; all it lacks are some technological breakthroughs. If the pulsed laser could be produced inexpensively and if its dangers could be minimized, holographic snapshots, wall pictures and ancestral viewing rooms might become common household features. □

The Father of the Hologram

Dennis Gabor, the man who invented holography, is an engaging and courtly research engineer who has been thinking about the nature of photographic images and the action of light waves ever since he was an inquisitive 17-year-old student in his native Budapest. The son of a director of a mining company (and unrelated to the show-business Gabors), he went to school in Germany and earned his doctorate in electrical engineering in 1927. He worked for a few years there, having as one of his lab assistants another Hungarian, Peter Goldmark, later president of the Columbia Broadcasting System laboratories and inventor of the long-playing (LP) phonograph record. Goldmark recalls that Gabor often rewarded his assistants for interesting lab work by giving them a present of Hungarian salami.

In 1933, just before Hitler came to power in Germany, Dr. Gabor went to England and found himself jobless in a depression-struck country. But he brought to officials at British-Thomson-Houston, an electrical-equipment manufacturer, a gas-arc lamp he had invented. It was never produced commercially, but it landed him a job developing a long line of electrical innovations from new lamps to television. In 1949 he joined the faculty at the Imperial College of Science and Technology, London University, and today he is professor emeritus of applied electronic physics there.

In the last years before Gabor left British-Thomson-Houston he produced the first hologram, the idea of how to do it emerging from his unconscious one fine Easter morning in 1947. He conceived holography as a way to perfect the electron microscope to the point where individual atoms could be seen with it. (Normally, the microscope lens blurred when viewing such tiny subjects as atoms: holography was a way to render the atoms visible by reconstructing them with light waves.) When the first applications to the electron microscope were unsuccessful, however, Gabor concluded that he was "twenty years ahead of my time." He was almost correct: some 16 years later, in January 1964, he read on the front page of *The New York Times* about a group of scientists at the University of Michigan who had applied the recently invented laser beam to holography. His own invention did not pass him by, however. He has remained a leader in the work. Today he has some 100 patents, many of them related to holography. They include a panoramic hologram that hangs on a wall—turning on a light creates a three-dimensional scene where there had been blank space—and a holographic motion picture screen. "Most of the best ideas," he says, "come outside the laboratory. The bathroom is an excellent place. So is the train."

Dr. Gabor's best idea—holography—was responsible for his winning the Nobel Prize in physics in 1971, an honor he admitted he was genuinely surprised to receive. On learning of the Nobel award while he was in America, he said in an interview, "I feel that I'm very, very lucky. Every Nobel winner is

A two-dimensional clue to the three-dimensional nature of holography is provided by this photograph of Dennis Gabor, the inventor of the process, standing next to a hologram portrait of himself. The hologram shows Gabor at a desk with the plans of his invention. It details in exact replica and in three dimensions—which cannot be seen on a printed page—everything in an area eight feet square by five feet deep. Like all holograms, it is not so much a picture as a precise reconstruction of a scene, in depth, through the careful manipulation of light waves.

lucky, but I'm extra lucky. Most people get the Prize for work done in the front line of science. I have found a nugget far behind the front lines. Also, I'm an outsider. I worked in industrial laboratories most of my life, and industrial workers rarely get Nobel Prizes."

A short man with thinning hair, a gray, bristly mustache and bushy eyebrows that tend to shoot up as he speaks, Dr. Gabor looks and acts younger than his years. Elegant in manner and bearing, he is a man who relishes the art of conversation. He and his wife lead an active and peripatetic life, spending half the year in the United States, where since 1951 he has been associated with the CBS laboratories run until recently by his old friend Peter Goldmark. The rest of the year the Gabors divide between London, where he gives occasional lectures, and a spacious villa that overlooks the Mediterranean just south of Rome at Anzio.

Dr. Gabor, an articulate commentator on man in society, has written three books on the subject of the future—*Inventing the Future, Innovations* and his latest, *The Mature Society.* On this topic, he says with conviction, "the last beautiful future was painted by Edward Bellamy in the 1880s in *Looking Backward.* . . . Let's invent a future—a good one—one that preserves the values of civilization and yet is in harmony with man's nature." ☐

When Seeing Is Not Believing

The picture at the right, like the frontispiece for this chapter *(page 123),* is a trick done not with mirrors but with a hologram: the fingers that seem to hold a solid toy are actually empty. The trick's purpose is not so much scientific as instructional, for it is meant to show in a conventional two-dimensional photograph the three-dimensional aspect of holography.

The demonstration was set up by LIFE photographer Fritz Goro in a laboratory at the University of Michigan with the aid of Professor Emmett Leith and research engineer Juris Upatnieks. In making the transmission hologram for Goro's photograph they used basic geometric figures—such as a pyramid, a sphere and a hexahedron—as well as the solid block letters that spell HOLOGRAM, because such objects are able to suggest three dimensions in the two-dimensional photograph. At first, the figures were cemented on a wooden block; this and the holographic equipment were placed on a seven-ton slab of granite resting on inflated rubber tubes to ensure utter immobility

—the hologram required an exposure of five minutes and any motion would have ruined it. In Goro's picture, exposed for only a fraction of a second, the figures are re-created from the holographic patterns by a laser beam directed at the glass plate, transforming the patterns into images that look like small pieces of sculpture seen through a window.

Such realistically three-dimensional images have been possible only since 1964—and their implications are still sinking in among the scientific and industrial establishments. Some of the refinements—as astonishing as the first hologram was—and their uses, either practical or theoretical, are described on the following pages. Among them are big-picture holograms made possible by the powerful pulsed laser; holograms that can be viewed without a laser, illuminated by an ordinary light source; holograms used for displays, materials testing, and compact storage and retrieval of pictorial or printed matter; and—still on the frontier of photography—the hologram in full color.

Demonstrating one of the remarkable attributes of ▶ holography—creation of a realistic image in three dimensions—Professor Emmett Leith of Michigan grasps a toy-sized pyramid. Or does he? Look again; the mirror at the left shows his hand to be empty. For the pyramid and its companion figures exist only as patterns within the glass plate, a transmission hologram. The star-shaped light shining out between the mirror and the hologram is the laser beam that makes the figures visible.

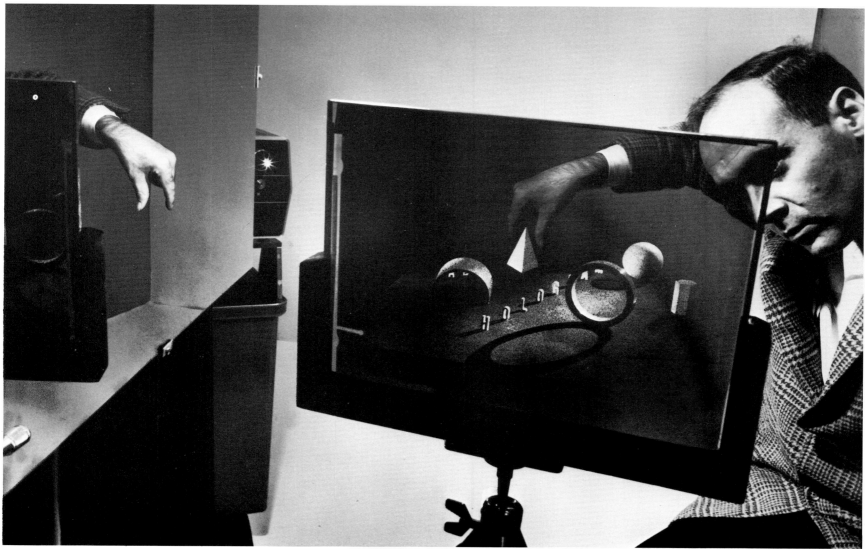

FRITZ GORO: *Two Views—Hologram and Mirror,* 1968

149

Big Pictures with Pulsed Lasers

Until the recent introduction of a special kind of laser, holography was restricted to subjects that were small, motionless and inanimate. Holograms require considerable amounts of light, and objects half a foot high were the largest that could be covered. But holograms are also greatly affected by even microscopic movement in the subject. No living thing—not even a piece of fruit—could remain still enough to be holographed by a steady-state laser, which provides relatively weak light and was for some time the only laser available. The infinitesimal expansions, contractions and slight alterations in shape that are a part of life would register an indecipherable blur on the holographic film.

This limitation was removed, however, with the advent in 1966 of the high-intensity pulsed ruby laser, which emits its light in bursts only billionths of a second in duration. These flashes are brief enough to stop not only the normal movement of living things but even a bullet shot from a gun barrel.

In order to illuminate a subject sufficiently with so brief a burst of light, the new pulsed lasers must be extremely powerful—at least 10 billion times brighter than the early steady-state lasers. They require ground-glass diffusers to protect a living subject's eyes from being injured by the intense strength of their light beams. Another requirement is an emulsion sensitive enough to catch an image in the ruby laser's 50-nanosecond flash.

Besides making it possible to make holograms of living things, the pulsed ruby laser eliminated the earlier limitation on the size of the subject. With the powerful new instrument, anything that occupies a space 8 by 10 by 10 feet can be holographed. A chair, a horse or a six-foot man *(right)* are now perfectly feasible subjects.

Although pulsed ruby lasers are still both hazardous and expensive—they cost $40,000 or more—they are the wave of the future in holography. Having brought large and moving subjects into range, they may one day (but not tomorrow) make holography practical for amateur picture-takers.

Bathed in the red glow of a pulsed ruby laser—but quite safe from its beam—D. C. Arnold, president of one of the companies that pioneered such lasers, sits for his holographic portrait, shown here in two views. From one viewpoint, at left, the lens he holds distorts the page on the desktop; from the other, it enlarges his wristwatch.

Mimicking Life for Display

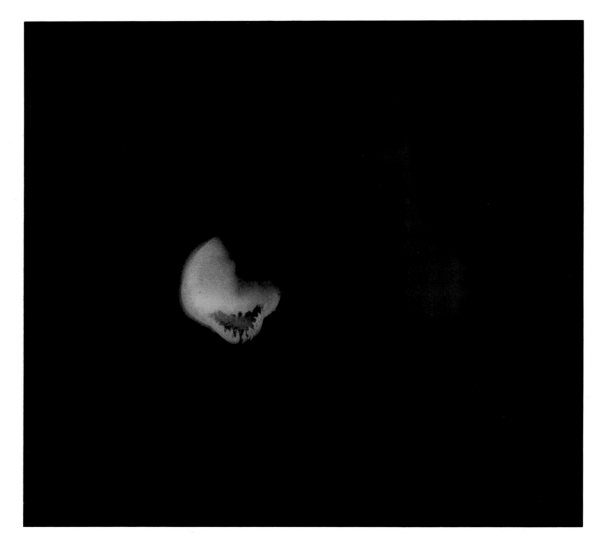

As menacing as a real creature glaring out through the glass wall of an aquarium tank, this holographic image of a plastic life-sized model of a shark was one of 13 pulsed-laser holograms of sea creatures that created an arresting vision of deep-sea life in a Florida museum. Its lifelike illusion of solidity suggests the applications that holography may one day find in advertising and for studying museum exhibits in schools.

What looks like three sharks swimming abreast ▶ is actually a picture showing three of the numberless views recorded on one pulsed-laser hologram. The hologram is actually red in color because it was made with a ruby laser, like those on the preceding pages. To give the scene a sea-green glow, a green filter was placed over the light illuminating the hologram. Three exposures were overlapped to give, within the limits of this two-dimensional page, a sense of the hologram's three-dimensionality.

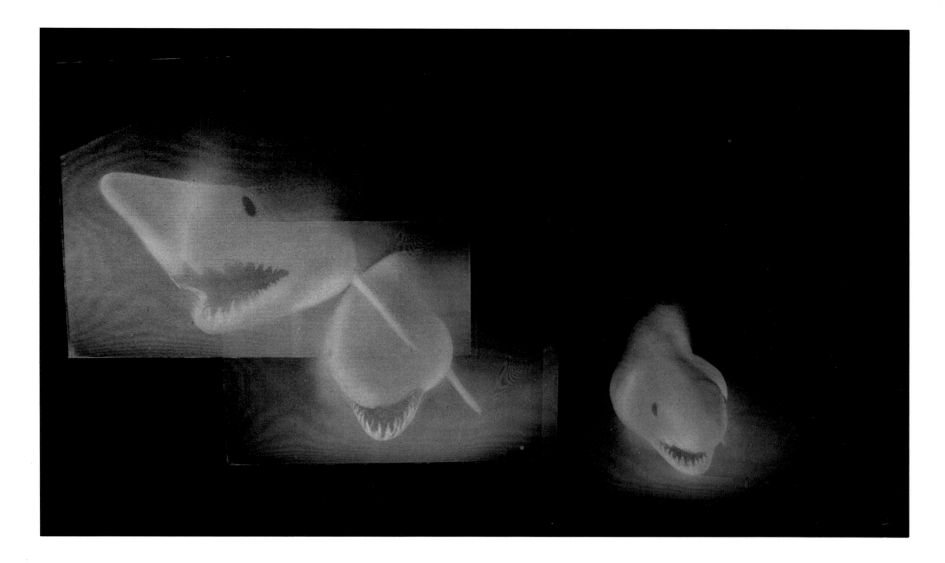

Light Patterns That Reveal Imperfections

Because holography is so sensitive to the slightest alteration in an object's position and shape, its most important applications to date have been in the field of measuring and testing by interferometry. Holograms study the shock wave created by a bullet in flight, probe tires and aircraft panels for deformations caused by stress, and establish standard shapes for critical parts.

What counts for testing is not the three-dimensional image a hologram can create but the swirling interference pattern on film. When two holograms of a subject are superimposed, the swirls of their light patterns coincide only if the subject has not moved or altered shape. If there has been any change, the slight difference in the holograms causes light waves passing through them to interfere and produce a shimmering pattern called moiré—it is the same effect seen when light plays across certain textured silks or when two pieces of wire screening are superimposed. Thus an infinitesimal crack in a casting, for instance, will change the casting surface by the merest fraction of an inch, but just enough to create the moiré effect in a pair of holograms. A similar effect would be produced in comparing two objects, like spheres, if their shapes were not identical.

A flaw in a tire is revealed (left) by the silklike pattern that appears when two holograms of the tire are superimposed on one film. One was made under normal conditions, the other under stress. The twisting whorls along the center of the double hologram indicate an abnormality, such as a bad bond between plies. The bar passing horizontally through the picture is a brace to hold the tire's sidewalls open during the examination.

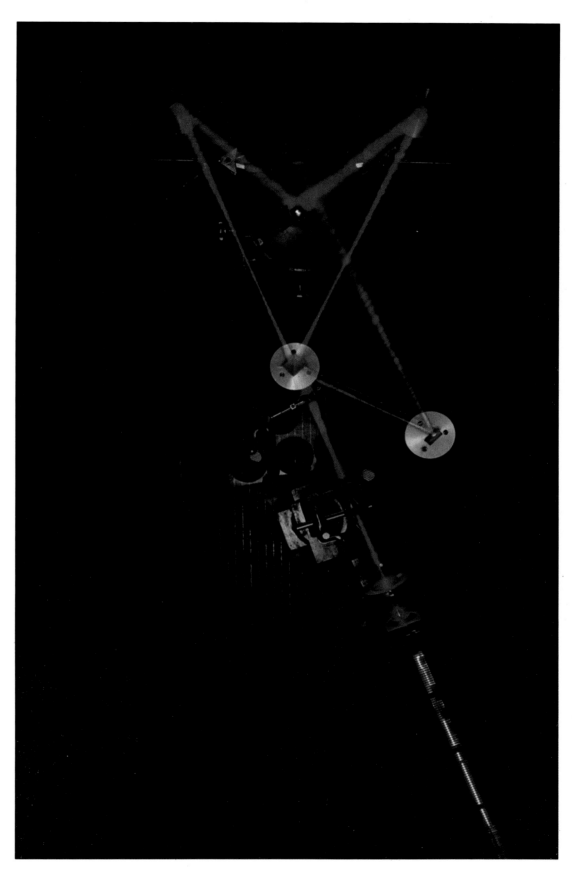

An absolute standard for the roundness of a sphere was sought by scientists in a hologram made with this elaborate setup at the National Bureau of Standards. A laser beam, directed from the lower right, is split by a prism into three parts. Mirrors at top direct two of the beams, which meet on the sphere between and below them; a reference beam bounces from a third mirror at right center onto the film behind the sphere.

Storing a Library in a "Sugar Cube"

Of all the practical applications of holography, few are so dazzling as its capacity for filing a great amount of information in a small space from which the material can be withdrawn instantly. Storing and retrieving information, traditionally a tedious and error-prone form of human drudgery, has already been speeded up immensely by computers. It will be accelerated incredibly by the marriage of the computer and holography—the offspring of which will read out in a few millionths of a second any of its millions of holographically stored pictures or words.

Thanks to the versatile laser and to the invention of the small crystal cube glowing in the picture at right, that union may not be far off. The cube —only one centimeter in size—theoretically can store as much information as is contained in a 50,000-volume library; what is more, it can deliver any portion of that information in 20 millionths of a second, or less time than it takes to blink. The laser and the cube store desired information—photographic views or photographic copies of printed material—that have been reduced to fractions of a centimeter in size. These images are thrust by a laser beam into the cube, where they remain packed like oranges in a crate until a laser fetches them out.

The cube is a colorless synthetic crystal that looks like glass and is made of either lithium niobate or barium sodium niobate, the latter dubbed banana because of its chemical formula, which is $Ba_2NaNb_5O_{15}$. A laser-borne image entering the cube alters electrons within the banana molecules, establishing a pattern, an electrically charged hologram corresponding to the image. But the electron pattern is unstable, can be read out only once and would shortly self-erase if left to itself. Heating the cube to a temperature of more than 200° converts this pattern of electrons into one composed of ions—electrically charged groups of atoms. This ion pattern stays put to be retrieved by laser light, which is affected by an ion pattern in the same way as by an emulsion pattern in a holographic plate. Theoretically, the cube's capacity to store holographic images is all but unlimited. In practice, however, the scientists have some bugs to work out; for example, the ion patterns, though relatively permanent, actually tend to fade away after a few months.

In the photograph at right, the retrieving laser light originates in an instrument off camera, at upper right, and shines onto the mirror at the upper left, then travels to the cube, which redirects it—bearing the image that it has fetched—onto the glass plate at the lower left. The remaining two blue beams leaving the cube are scatterings of the laser light; the other instruments are beam splitters and mirrors used to embed the image in the cube. Rotating the cube or turning the laser beam will extract different images from inside the crystal, like photographic slides from the tray in a projector.

A crystal cube about the size of a lump of sugar, ▶ sitting atop a turret mounted on a turntable, yields an image of the entrance to the RCA laboratories in Princeton, New Jersey, projected onto a frosted glass screen (lower left corner). The image, a holographic reproduction of an ordinary two-dimensional picture, was written into the cube as an atomic pattern, then retrieved from the crystal and cast onto the screen by laser light.

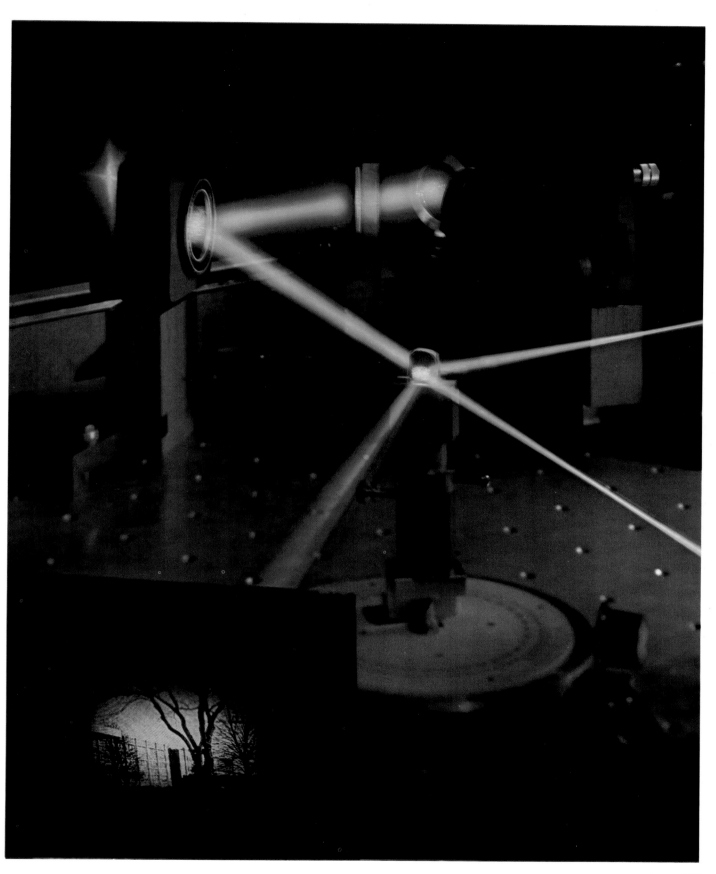

Holograms in Color

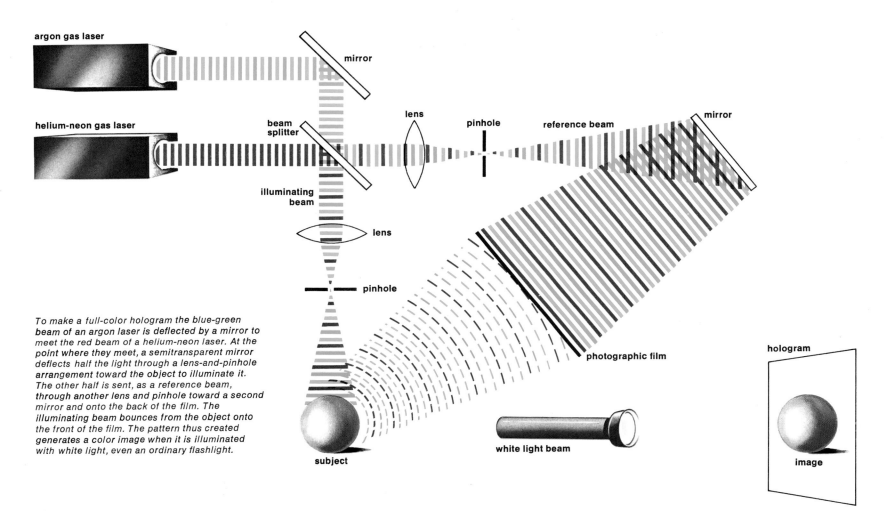

argon gas laser

helium-neon gas laser

mirror

beam splitter

lens

pinhole

reference beam

mirror

illuminating beam

lens

pinhole

photographic film

subject

white light beam

hologram

image

To make a full-color hologram the blue-green beam of an argon laser is deflected by a mirror to meet the red beam of a helium-neon laser. At the point where they meet, a semitransparent mirror deflects half the light through a lens-and-pinhole arrangement toward the object to illuminate it. The other half is sent, as a reference beam, through another lens and pinhole toward a second mirror and onto the back of the film. The illuminating beam bounces from the object onto the front of the film. The pattern thus created generates a color image when it is illuminated with white light, even an ordinary flashlight.

As lasers become more sophisticated, so do the holograms they can produce. One of the most fascinating developments in holography employs two lasers instead of one and produces a three-dimensional image in full color.

The two lasers used for a color hologram project beams of different colored light. One, a helium-neon gas laser, produces a red beam. The other, a newer argon gas laser, produces a beam of blue-green. The two beams are combined to provide a mixture of light containing the three primary colors —red, blue and green. The multicolored combination is then split in two; one half becomes the reference beam, and the other half becomes the beam illuminating the object.

These reference and illuminating beams intersect on photographic film coated with ordinary fine-grain black-and-white emulsion. However, instead of intersecting on one side of the film, as in transmission holography *(diagram, page 137),* the two beams approach the film from opposite sides. The reference beam strikes the back surface of the film, the illuminating beam strikes the front, and the two meet and mix deep within the emulsion to form multiple layers of interference patterns. When a beam of white light is directed at this "deep" hologram, the light bounces from its various layers in such a way that colors are generated as well as the three-dimensional image —and the reconstructed colors are identical to those of the original object.

A New Wave of Abstraction

ERICH HARTMANN: *Laser Light*, 1971

Pushing beyond Reality

Photography long ago achieved its primary goal: to record reality. And to-day, thanks to advances in equipment, it can reveal and interpret the world in ways that an earlier age would have thought miraculous. Many a photographer, brought up to work toward this goal of realism and to believe that the fewer questions a picture raises the better, approaches the ambiguous, what-is-it realm of abstract photography with great suspicion. Understandably he feels that if it is abstract, then it is not photography—not the way he learned it. Only by pulling a mental switch, an act that can be something of a wrench, can he bring himself to accept the nonobjective, nonrepresentational kind of picture as being just as legitimate as the picture that deals with the familiar world in a straightforward way. But once he does, he is likely to cross the frontier into abstraction himself, as increasing numbers of his fellow photographers are doing, there to revel in the freedom *not* to be concerned with everything he is used to.

For the abstract photographer, explains Ernst Haas, who took the plunge a long time ago, "the object is totally unimportant; the subject matter is yourself—your feelings and reactions to what you see—and you express yourself through form and color." Not only that, but there is no limit to the directions self-expression may take. It may involve complex manipulations with special lenses and darkroom equipment, dispense with the camera altogether, or use the standard gear of photography. Harald Sund, shooting an ice cave high on a mountainside, did not even try to reproduce a recognizable image of the ice cave but instead sought to capture its essential qualities. His photograph *(page 166)* could never be used to identify that particular ice structure, yet through its color and shape the picture eloquently suggests the isolation and cold beauty of the cave.

The exploration of abstract photography, as avant-garde as it may seem, is no new phenomenon. In fact it can be said to antedate the invention of the camera itself by more than a century, for in the 1720s the German scientist Johann Schulze experimented with photosensitive mixtures of silver salts by exposing them to light through stencils in which words were cut.

The two men generally credited with laying the foundations of abstraction were two painter-photographers, Man Ray, an American working in Paris, and László Moholy-Nagy, a Hungarian working in Berlin. In their 1920s experiments, in which they exploited such still-used approaches as shadow pictures, multiple exposure, photomontage and tone reversal, they sought to fulfill what they believed to be photography's mission—to investigate the "pure" actions of light in space.

Less well known are the innovations, a few years earlier, of Alvin Langdon Coburn, a Bostonian expatriate in England. Inspired by the abstract works of 20th Century painters, Coburn asked in print: "Why should not the camera

The poet Ezra Pound appears in one of a series of Vortographs, made with a mirroring device that acted as a prism to split into segments the image in front of the camera. Pound's espousal of avant-garde literary and artistic movements was a source of inspiration to the creator of these pioneer abstract photographs, Alvin Langdon Coburn; and Pound in turn was delighted by Coburn's efforts to liberate photography from what he described as "the material limitations of depicting recognizable natural objects."

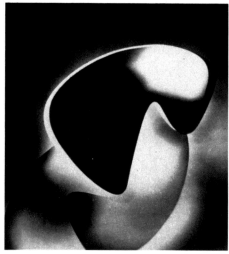

Two cameraless prints, or photograms, made by Man Ray (top) and László Moholy-Nagy (bottom) forecast some of the directions photography was to take in the search for new forms and designs. Although Ray and Moholy-Nagy worked independently, both experimented endlessly in remarkably similar ways with photographic prints, and were fascinated by the artistic potential in contact printing. By arranging three-dimensional translucent and opaque objects on light-sensitive paper, they recorded not only shadows, but also the objects' inner structures and textures.

also throw off the shackles of conventional representation and attempt something fresh and untried? . . . Why, I ask you earnestly, need we go on making commonplace little exposures of subjects that may be sorted into groups of landscapes, portraits, and figure studies? Think of the joy of doing something which it would be impossible to classify, or to tell which was the top and which was the bottom!" Coburn made the then-scandalous suggestion that an exhibition devoted exclusively to abstract photography be organized, and that "in the entry form it be distinctly stated that no work will be admitted in which the interest of the subject matter is greater than the appreciation of the extraordinary."

But the interest in abstract photography that grew during and after World War I faded rapidly with the close of the hectic '20s. Not until after World War II was there any resurgence of fascination with the field. Then, as in the years following the First World War, cynicism and disillusionment with the establishment led to a disintegration of accepted conventions in art. "The emphasis of meaning has shifted," commented Aaron Siskind in the 1950s, "from what the world looks like to what we feel about the world and what we want the world to mean." The new abstractionists, like their predecessors, at first met with a good deal of resistance, from other photographers as well as the public. In 1951, the renowned photographer Berenice Abbott wrote scathingly: "The imitators of abstract painting, the photographers of the pure design . . . I think this represents the end [of photography]." Even a decade later, the respected critic Helmut Gernsheim dismissed nonobjective photography as "a negation of everything that is truly photographic: in short, photographic suicide."

But today the abstract photograph is welcomed as a new form of serious art. This turnaround has come partly because realism has done its job perhaps too well. Pictures have nearly replaced words as the means of communicating ideas; we are so saturated by dynamic visual images—in magazines, newspapers, billboards, advertising circulars, movies and television—that we have learned to select (or abstract) from concrete images the essential message. A picture that is already abstracted is no surprise.

And so, given a wider critical and popular recognition of the abstract photograph as a legitimate form of art, the future is wide open. Besides the many professional photographers who have been working with abstract images for years, there is a multitude of young people unconcerned with the formal conventions of photography; they see the camera simply as a tool and the printing paper as a canvas. Such photographers recognize no predetermined limitations or fixed horizons to creativity; they refuse, in fact, to be bound by what the distinguished photographer Minor White once described as "the tyranny of visual facts." □

Three Avenues of Expression

One pleasant advantage of abstract photography is that it is not beyond anybody's reach—or aspiration. The photographer may employ the simplest techniques, or the most complicated. And in choosing what to photograph, he can really let himself go—anything is acceptable that he finds esthetically satisfying and self-expressive. There is no one-and-only subject or style of abstract photography, as becomes evident in the picture gallery that begins at right. But while the ways and means in this field are almost limitless, it is possible to separate the work that follows into three basic approaches.

Most familiar is the photograph that isolates a physical object from its surroundings and dissociates it from reality, displaying it not for its identity or function but solely for its graphic qualities: its shape and volume, its color, texture and pattern. The subject is a real thing—a sand dune, an ice formation, a woman's profile—that can be seen and recognized by the human eye, but its meaning is transformed. Even such a homely object as an old tin can *(page 170)* can be photographed for form rather than function, acquiring greater interest than it ever had in real life. All that is needed is the eye with which to recognize design potentials.

In another approach to abstract photography, the photographer relies on picture-taking or darkroom techniques to create images that do not ordinarily meet the eye. He does not use everyday subjects as a jumping-off point for his compositions but creates the abstrac-

tions himself—arranging snips of colored paper into designs that are then reflected for the camera's eye to catch *(pages 178-179)*, or making his own color negatives by painting glass with oils *(page 184)*, or treating sensitized paper with chemical stains *(pages 190-191)*. These images cannot be seen beforehand by the viewer; they exist only in the photograph. Even when the picture is based on a real subject, such as a piece of Venetian glass *(page 188)*, it is not the surface of the glass that is photographed but the color patterns within it, so that no one looking at the glass sees it as the camera does.

A third kind of abstract photograph has been inspired by—and made possible by—technology. Since its earliest days, photography has incorporated other instruments and techniques of research for practical purposes: to record discoveries, to make visible the invisible (by means of special films) and to expose the minuscule (with the help of a microscope). But today, many photographers put the tools of science to work in the interest of esthetics, manipulating light waves to reveal startlingly beautiful colors and designs within ordinary substances *(pages 194-195)*, and employing the brilliant concentrated beam of the laser to capture pure light on film in graceful patterns *(page 161)*. Whatever the approach, abstract photographers are striving more and more to free photography from its role as a recording mechanism, and to open it up to every imaginable avenue of artistic expression.

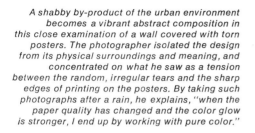

A shabby by-product of the urban environment becomes a vibrant abstract composition in this close examination of a wall covered with torn posters. The photographer isolated the design from its physical surroundings and meaning, and concentrated on what he saw as a tension between the random, irregular tears and the sharp edges of printing on the posters. By taking such photographs after a rain, he explains, "when the paper quality has changed and the color glow is stronger, I end up by working with pure color."

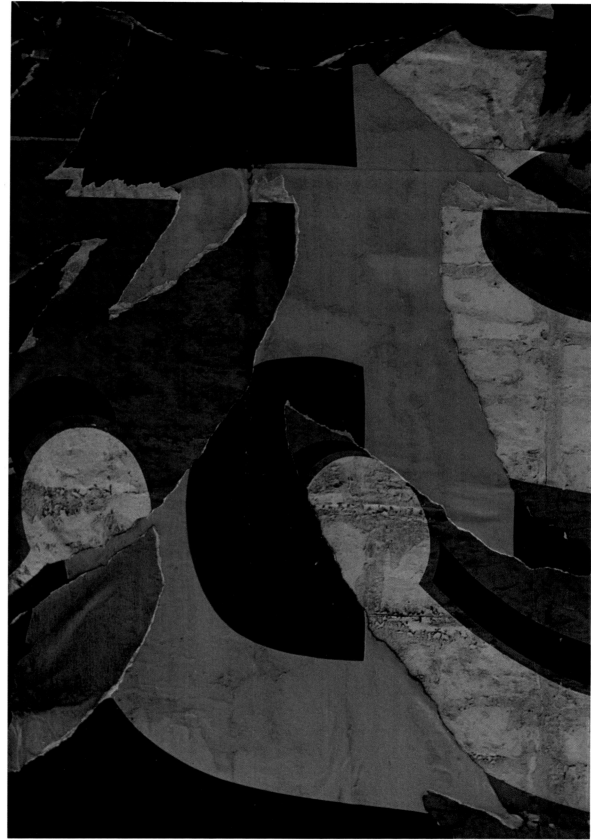

ERNST HAAS: *Torn Posters*, 1968

Transforming the Familiar

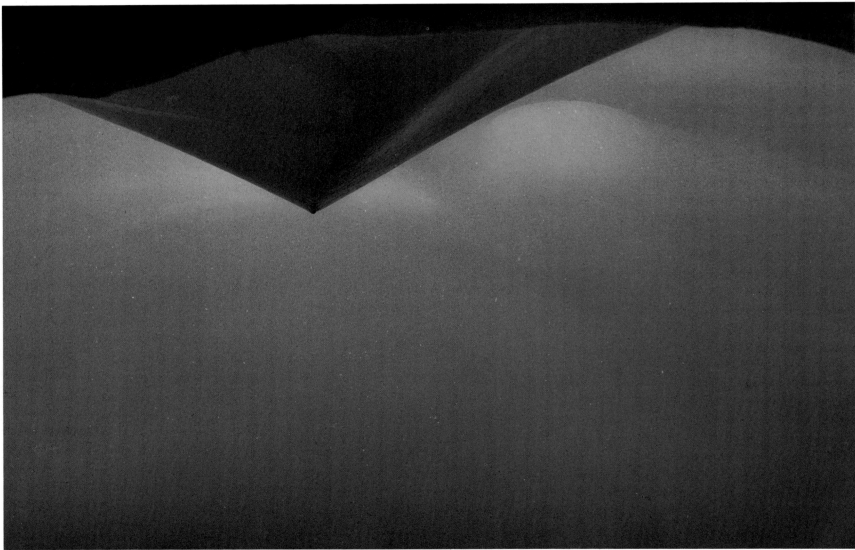

HARALD SUND: *Ice Cave*, Mount Rainier, 1969

Just as anything under the sun can serve as subject matter for "straight" photography, virtually anything—faces, buildings, landscapes or machinery —can be used as the raw material for abstract pictures. All the photographer needs is his eye, for this kind of picture is produced with ordinary photographic equipment and techniques. If the eye can recognize the design potential in the otherwise commonplace and mundane—and if it can exclude the irrelevant—the camera can do the rest: it can, for example, capture the essence of an ice cave by concentrating on its color *(above),* or reveal the beauty in paint blisters *(right)* or in a contorted pile of scrap metal *(page 171).*

ERNST HAAS: *Peeling Wall*, 1967

◄ *The cold brilliance of an ice cave, revealed
entirely in color and shape, conveys the essence
of frigidity as no representational picture could
do. The extraordinary blue is a faithful record
of the color seen within the cave, not the result of
filters or after-the-fact color manipulation. It was
the glacier ice that created the color by filtering the
bright sunlight to absorb all but the blue rays.*

*The subject is actually an old painted wall, eroded
by time and the elements. The photographer's
eye, however, saw in the pebbled surface a
striking design (he even saw human forms in the
blistering paint) and he made the texture, color and
patterns themselves the subject of his picture.*

167

An extraordinary impression of an ordinary sand dune dramatizes the formation's contours and texture. The original transparency of the burnt-orange dune was copied through an orange filter, intensifying the contrast and richness of the color.

PETE TURNER: *Sand Dune*, Egypt, 1964

The strong curves of the sand dune shown at left are emphasized in the second, more complex variation at right. The photographer made two copies of the original transparency, one through a green filter and the other through a magenta filter; these copies were made on color-slide film and processed not to produce positive transparencies, but into color negatives by means of a negative color developer, which reversed the colors. The negatives were then sandwiched together and copied for the final positive transparency.

PETE TURNER: *Sand Dune*, Egypt, 1964

STAN LEVY: *Tin Can,* 1971

A tin can, crushed into the asphalt pavement by automobiles, symbolizes the decay of the city to Stan Levy, who walks the streets with downcast eyes looking for smashed cans to photograph. His goal is "to snatch some visual meaning from the jaws of chaos," and he seeks it in these machine-age discards. Aside from coping with the technical difficulties of shooting at ground level —which necessitates the use of such unusual accessories as cushioned kneepads—Levy must work quickly or risk getting run over by traffic.

When photographed out of context and apart from its surroundings, a battered pile of scrap metal in a junk yard no longer has literal meaning. The end products of technology—wrecked automobiles, discarded stoves and washing machines—exist in the photograph at right only for their vivid colors, varying textures and twisted shapes.

HARALD SUND: *Scrap Iron*, 1970

GEORGE E. OBREMSKI: *The Solomon R. Guggenheim Museum,* 1969

◄ *A multiprinted impression of Frank Lloyd Wright's complex Guggenheim Museum in New York City evolved from a single black-and-white negative —an interior shot of the museum from ground level, looking up at the glass dome. The negative was printed on two separate sheets, then turned over to flop the image left-for-right, as in a mirror, and printed on two more sheets. Next, four other prints were made (again, two were flopped), and these last four were cut in half; four of the halves were discarded. The eight remaining whole and halved prints were assembled into a design; then the composite was copied onto a color transparency, which imparted the antique tone.*

Beginning with one black-and-white negative showing the corner of a skyscraper, the photographer made 16 separate prints; for half of them, the negative was flopped to create reversed images in the positives. All of the prints were gathered into one geometric pattern and the assemblage was copied twice through a blue filter to produce identical color transparencies. These were sandwiched together, after one of the transparencies had been rotated 180°, to achieve an even more complex linear pattern.

BILL McCARTNEY: *Untitled,* 1971

For a colored abstraction of a skyscraper, part of a series of photographic impressions of New York City, Mitchell Funk made five exposures—each one through a different color filter—on one frame of color-slide film. The first exposure was a close-up of the building. The camera, set on a low tripod, was then shifted progressively from left to right for the four remaining exposures. The film, which is intended to produce positive transparencies, was then developed as a negative. Each of these successive manipulations— filtering, multiple exposure and processing —altered the colors by adding tones, combining them and reversing them. The resulting design, by now many times removed from reality, is a jewellike wedge of luminous, unexpected hues.

MITCHELL FUNK: *Building No. 6*, 1971

To lend a romantic aura to the strong angular lines of the city, the photographer set his camera on a low tripod and made four exposures on one frame. The first exposure was made through a deep blue filter with the camera fixed at a slight tilt. During each succeeding exposure the camera was swung upward through an arc while the shutter was open. One such exposure was made through a deep red filter at ¼ second; another through a deep purple filter, also at ¼ second; and the last through a yellow filter at ⅛ second.

MITCHELL FUNK: *Lower New York,* 1971

JAY MAISEL: *Profile*, 1970

◄ The photographer was walking with a friend one night when he saw her silhouetted against a store window display—actually a large illuminated red heart. On impulse he shot a close-up of his companion, emphasizing her shadowed profile against the solid block of color so that the line itself, divested of any relationship to the woman's face, became the real subject of the picture.

A curiously flowerlike photograph, in which the design seems to rise from a luminous "vase," was made from a 35mm color transparency and its copy. The two transparencies were placed back to back and fastened together, creating a double silhouette. The sandwich was copied for the final transparency, dominated by the twin profiles, with the model's hair and shoulder barely suggested.

ALAN I. KAPLAN: *Consciousness*, 1969

Things Only the Camera Can See

The abstract photographer need not limit himself to the real world—rich as it is in subject matter—for his inspiration. He can figuratively create his own world, in which he synthesizes the images he shoots instead of extracting them from natural sources around him. Freed from the demands of reality, he can experiment in countless ways: by composing a design, then reflecting it for the eye of the camera to capture *(right);* by replacing the camera lens with a doily and recording the light patterns directly on film *(page 187);* or by skipping the camera entirely and painting abstract designs on glass with oils, thus producing an artificial color negative *(page 184).* In all such pictures the human eye cannot appreciate (and often cannot even see) the abstract image that is created; it comes to life only in the final photograph.

Origami—the Japanese art of folding paper—was the beginning point for a composition that is totally divorced from anything anyone ordinarily sees with his own eyes: an unusual example of abstractions made of manufactured images. Several stages of synthesis were involved. Strips of colored paper were first pasted down on white cardboard. This assemblage was placed above a sheet of polished aluminum, which acted as a mirror. The flexible metal sheet was twisted to distort the design, and the flowing colors in the contorted reflection were then photographed.

NOB FUKUDA: *Untitled*, 1971

BILL LONGCORE: *Bubbles*, 1969

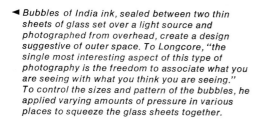

◀ Bubbles of India ink, sealed between two thin sheets of glass set over a light source and photographed from overhead, create a design suggestive of outer space. To Longcore, "the single most interesting aspect of this type of photography is the freedom to associate what you are seeing with what you think you are seeing." To control the sizes and pattern of the bubbles, he applied varying amounts of pressure in various places to squeeze the glass sheets together.

A haunting abstract landscape was created by pouring transparent colored inks onto a square plate of glass set over a light source. The photographer allowed the inks to flow freely and, when the colors and patterns were to his liking, shot a portion of the plate from above.

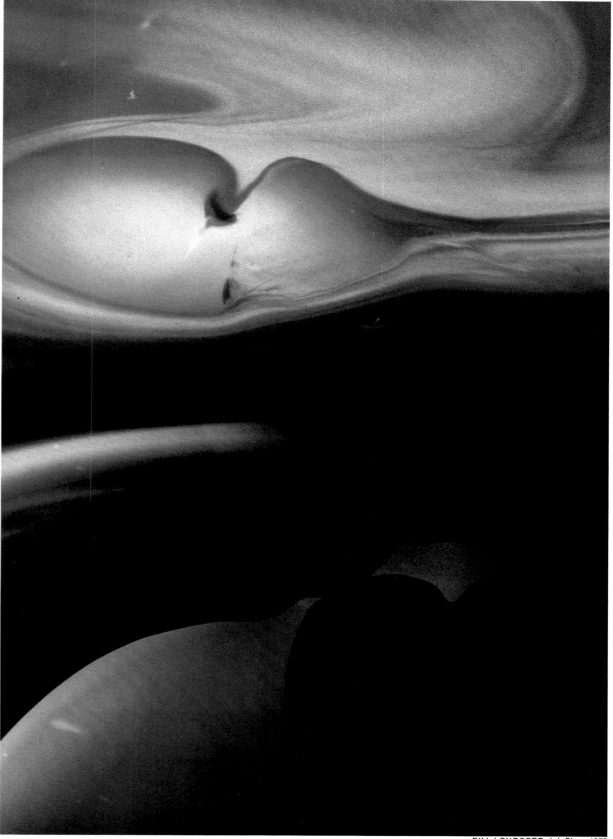

BILL LONGCORE: *Ink Flow*, 1970

HARALD SUND: *Film End*, 1970

◄ *While examining a roll of processed film, Harald Sund became fascinated by the two- to three-inch scraps (like the one at left) that are cut off from the ends of the roll, processed, and returned along with the transparencies. Sund considers many of these unplanned by-products of photography as interesting visually as the pictures he shoots with carefully controlled lighting and composition. He now examines all film scraps and, while discarding most, saves for display those whose colors and shapes catch his eye.*

A whole week's work and a wide range of techniques went into the making of this complex composition. It began simply enough, with a self-portrait. The black-and-white negative was then copied onto high-contrast film, producing a positive transparency that stressed only the essential black-and-white elements of the portrait. The copy was used to make a silk-screen print (pages 74-77) on translucent paper using thinned inks. This print in turn was treated as if it were a color negative; it was placed beneath a light source and contact printed onto color printing paper that had been pre-exposed with a blue-filtered light. Only the photographer could know he was the source of the final abstract image.

ALBERT LUNT: *Self-Portrait*, 1971

GEORGE E. OBREMSKI: *Untitled,* 1970

The example of cameraless photography at left was made by painting colored inks on glass to create an artificial color negative. The "negative" was then printed normally on color printing paper.

Several steps were needed to produce this ▶ picture, created entirely outside the camera. Four pieces of black-and-white film were made opaque by exposing them to light and then developing them; the photographer then burned them over an open flame to cause the emulsion to bubble and char for a spongelike effect. The manipulated negatives were printed separately on black-and-white printing paper, the prints were handpainted in oils to accentuate their form, and all four were assembled for the final composite print.

GEORGE E. OBREMSKI: *Untitled*, 1970

LEN GITTLEMAN: *Photogram*, 1971

◄ *Long a favorite of photographic experimenters,
the cameraless shadow picture, or photogram
—made by placing an object on sensitized paper,
exposing it to light, then processing the paper
—is transformed by the use of color materials. In
this example, pieces of colored paper laid
on color printing paper have blocked or altered
the light to create strong lines and shadows.*

*Patterns of colored light were captured on color
film in the photographer's darkened living room.
The camera was placed on a tripod pointing
upward and the lens was removed; in its place the
photographer set a lacelike paper doily. Above
the camera was the light source, an enlarger
fitted with a green filter. The green light passed
through the textured doily directly onto the
camera's film, making a delicate color image.*

STEPHEN ALLEN WHEALTON: *Untitled*, 1968

Intrigued by the transient color imprisoned in a
Venetian glass bowl, the photographer added an
extension tube to his 50mm lens to magnify the
subject. He then opened the lens to its widest
aperture (f/2) to get shallow depth of field
and focused beyond the surface of the glass to
capture its color as a soft, liquid flow of light.

STEPHEN GREEN-ARMYTAGE: *Venetian Glass*, 1965

The swirling, multicolor design in a piece of fabric suggested movement to the photographer, who accentuated this feeling with a deliberately distorted picture. Setting his shutter at the slow speed of ⅛ second, he moved the camera from left to right as the shutter opened, to blur the pattern and indicate on film its quality of motion.

STEPHEN GREEN-ARMYTAGE: *Fabric*, 1971

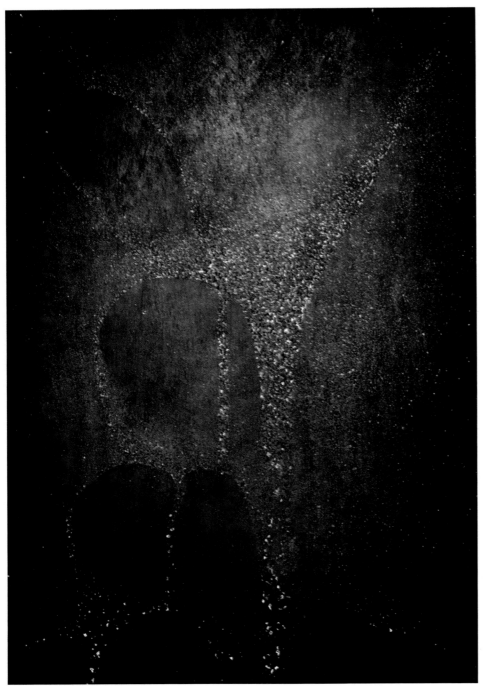

Black-and-white printing paper was exposed to the light and then treated with chemicals for this sparkling picture, suggestive of the fiery trail left by a skyrocket in flight. The chemicals were developing and fixing solutions used in black-and-white processing. When poured onto the sensitized paper, they added color and design.

BILL McCARTNEY: *Untitled,* 1970

In another example of printing paper "painted" with chemical stains, the photographer exposed the paper to light, watched the image change as the chemicals worked and, when he saw a design he liked, halted the chemicals' reaction by fixing the paper. "I don't feel that I'm really the creator," he confesses, "I'm more like the midwife."

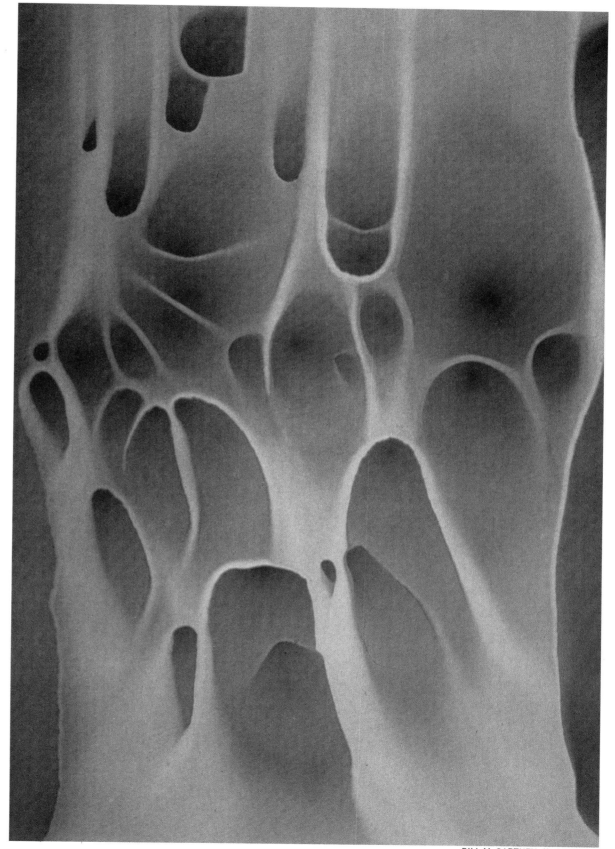

BILL McCARTNEY: *Untitled*, 1970

A World Made Visible by Science

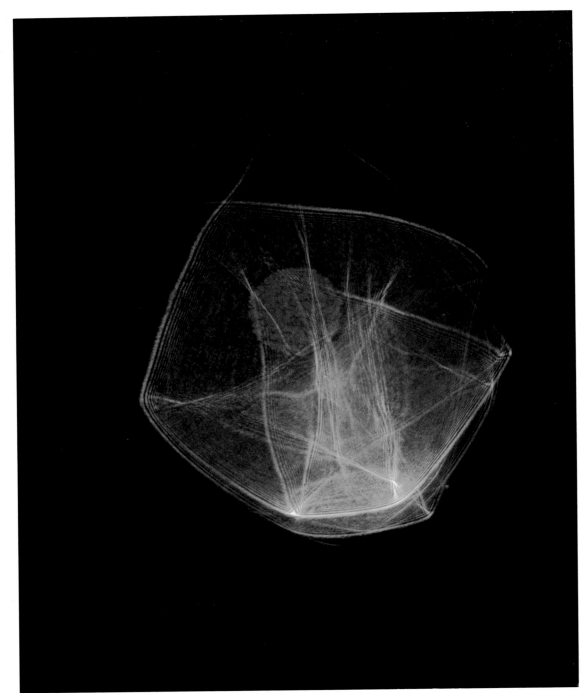

MICHAEL HELLER: *Abstract Atom,* 1971

Many photographers, not content to be limited by conventional photographic equipment—no matter how sophisticated it might be—are borrowing tools and techniques developed for scientific research to create new kinds of abstract pictures. In some cases, it is the scientific tool itself that has excited the photographer's imagination. The laser's thin, intense beam of light, which promises revolutionary gains in medicine, navigation and communications, provides a brilliant, concentrated color that makes it a unique light source for photography *(Chapter 5).*

Photographers have also been stimulated by the unexpectedly vivid colors and patterns found in pictures taken for scientific purposes, such as a naval research photograph made by the technique called dissection color schlieren *(page 196).* Older research techniques, too, are utilized today in new ways: photographers as well as scientists have long been intrigued by the unsuspected designs revealed when uninteresting substances are viewed through a microscope. And when polarized filters are added, photomicrographs, even of dull white drugs *(pages 194-195),* offer startling color effects that can be enjoyed simply for their beauty.

For this double exposure, a prism placed in front of an argon laser broke down its bluish-white beam of light into a spectrum of yellow, blue, green and turquoise lines. All lines but the turquoise were blocked off; rippled plastic was placed in front of it and the pattern it created was projected on a translucent screen and photographed. Then the red beam coming from a helium-neon laser was directed against the screen and was shot out of focus.

ELSA GARMIRE: *Laser Image*, 1970

The red beam from a helium-neon laser was
projected onto a screen and photographed by Dr.
Elsa Garmire, who had become fascinated with
the artistic opportunities offered by these unique
light-producing devices. The camera lens was
replaced with textured plastic, and the camera
was pointed at the light on the screen, which
shone through to create the pattern on the film.

The white powder norethindrone, a hormone used in birth-control pills, reveals new color and beauty when magnified 200 times and photographed with polarizing filters. One filter—the polarizer —limits vibrations in the microscope's light beam to one direction. The specimen itself then alters the unidirectional beam, dividing it into two components that travel upward into the microscope tube at different angles. When they reach the second polarizing filter—the analyzer in the eyepiece—the two beams interact, canceling some of the wavelengths and strengthening others, thereby producing new shades and hues.

JACK KATH: *Oceanic Space*, 1970

In this lavish color study, a white sulfur compound, sulfabenzamite, was magnified 400 times and photographed under the microscope with polarizing filters. The photographer experimented with the analyzer—one of the filters —changing its angle and position to alter the interaction in the light rays it admitted; in this way he could produce entirely new combinations of wavelengths and create colors to suit his fancy.

JACK KATH: *Micro-Autumn,* 1970

Shot originally as part of a research project investigating the impact of air on a ballistic-missile model in a wind tunnel, this photograph stands on its own artistic merit for its strength of color and abstract design. The pattern results from a technique known as dissection color schlieren, which the photographer developed for the Naval Ordnance Laboratory. The process is technically complex but depends on a phenomenon familiar in mirages—the bending of light waves by variations in the density of air. In this case, the variations are caused by the configuration of the model, which deflects the air passing through the wind tunnel. Color filters are used to make visible the air flows of different densities; in other words, the variations in air flows appear on film as variations in color.

PAUL H. CORDS JR.: *Air Flow*, 1969

Bibliography

General

Focal Press, *Focal Encyclopedia of Photography*. McGraw-Hill, 1969.

Gernsheim, Helmut, *The History of Photography*. Oxford University Press, 1955.

Gernsheim, Helmut and Alison, eds., *Alvin Langdon Coburn Photographer: An Autobiography*. Frederick A. Praeger, 1966.

*Lyons, Nathan, *Photographers on Photography*. Prentice-Hall, 1966.

Nature/Science Annual 1971. TIME-LIFE Books, 1971.

Newhall, Beaumont, *The History of Photography from 1839 to the Present Day*. The Museum of Modern Art, Doubleday, 1964.

†Scharf, Aaron, *Creative Photography*. Reinhold, 1965.

Stenger, Erich, *The March of Photography*. Focal Press, 1958.

†Taft, Robert, *Photography and the American Scene*. Dover, 1964.

Art and Photography

Kultermann, Udo, *The New Painting*. Frederick A. Praeger, 1969.

Rauschenberg: Graphic Art. Institute of Contemporary Art, Univ. of Pennsylvania, 1970.

Richard Hamilton. The Tate Gallery, 1970.

Russell, John and Suzi Gablik, *Pop Art Redefined*. Frederick A. Praeger, 1969.

Scharf, Aaron, *Art and Photography*. Penguin Press, 1969.

Special Fields

Brown, Ronald, *Lasers, Tools of Modern Technology*. Doubleday, 1968.

Caulfield, H. J. and Sun Lu, *The Applications of Holography*. John Wiley & Sons, 1970.

Dessauer, John H. and Harold E. Clark, *Xerography and Related Processes*. Focal Press, 1965.

Fishlock, David, ed., *A Guide to the Laser*. American Elsevier Publishing, 1967.

Handy and Harman, *The Silver Market 1971*. Handy and Harman, 1971.

Kallard, Thomas, ed., *Holography, State of the Art Review . . . 1970*. Optosonic Press, 1970.

Kick, Winston E., *Laser and Holography*. Doubleday, 1969.

Langford, Michael J., *Advanced Photography: A Grammar of Techniques*. Focal Press, 1969.

Lehmann, Matt, *Holography*. Focal Press, 1970.

Litzel, Otto, *Darkroom Magic*. Amphoto, 1967.

Mannheim, L. A., ed., *Perspective World Report 1966-69 of the Photographic Industries, Technologies and Science*. Focal Press, 1968.

Morgan, Willard D. and Henry M. Lester, *Stereo Realist Manual*. Morgan and Lester, 1954.

Recovering Silver from Photographic Materials. Eastman Kodak, 1969.

Society of Photographic Scientists and Engineers: *Applications of Photopolymers*, 1970; *Novel Imaging Systems*, 1969; *Reprints of Paper Summaries, 24th Annual Conference Photographic Science and Engineering*, 1971; *Unconventional Photographic Systems*, 1967.

Stroke, George W., *An Introduction to Coherent Optics and Holography*, 2nd Edition. Academic Press, 1969.

Valyus, N. A., *Stereoscopy*. Focal Press, 1966.

Periodicals

Art News Annual, Newsweek, Inc., New York City.

Arts in Virginia, Virginia Museum of Fine Arts, Richmond, Virginia.

British Journal of Photography, Henry Greenwood and Co., London.

Camera, C. J. Bucher Ltd., Lucerne, Switzerland.

Camera 35, U.S. Camera Publishing Corp., New York City.

Electronics Design, Hayden Publishing Co., Inc., New York City.

Electronics World, Ziff-Davis Publishing Co., New York City.

Modern Photography, The Billboard Publishing Co., New York City.

Photographic Applications in Science, Technology and Medicine, Photographic Applications in Science and Technology, Inc., New York City.

Photographic Science and Engineering, Society of Photographic Scientists and Engineers, Washington, D.C.

Physics Today, American Institute of Physics, Inc., New York City.

Popular Photography, Ziff-Davis Publishing Co., New York City.

Scientific American, Scientific American, Inc., New York City.

Studio International, Cory, Adams & Machay Limited, London.

X Magazine, 10/70, Deutsche Verlags Anstalt, Stuttgart.

* Available only in paperback.
† Also available in paperback.

Acknowledgments

For assistance given in the preparation of this volume, the editors thank the following: Juan J. Amodei, Quantum Electronics Research, RCA, Princeton, New Jersey; Carol Appelman, Nikon House, New York City; Byron Brenden, Holosonics, Inc., Richland, Washington; Walter Clark, Rochester, New York; R. J. Collier, Research and Development, Bell Telephone Laboratories, Murray Hill, New Jersey; Paolo Cardazzo, Galleria del Cavallino, Venice; Bill Gaskins, London; Matilde Gasparini, Milan; Ando and Lucianna Gilardi, Fototeca Storica Nazionale, Milan; Joseph T. Gennaro, Department of Biology, New York University, New York City; William Glenn, Director of Applied Research, CBS Laboratory, Stamford, Connecticut; Peter Goldmark, President of Goldmark Communications, Stamford, Connecticut; Fritz Gruber, Director of Photokina, Cologne; John S. Hamlin, New Rochelle, New York; Eric Hartmann, New York City; Brig. Gen. Lawrence P. Jacobs, American Society of Photogrammetry, Falls Church, Virginia; Herbert Keppler, Editorial Director and Publisher of *Modern Photography*, New York City; K. C. Kierzek, McDonnell Douglas Electronics Co., St. Charles, Missouri; Michael King, Research and Development, Bell Telephone Laboratories, Murray Hill, New Jersey; Edwin H. Land, President of the Polaroid Corporation, Rochester, New York; John E. Lapak, Agfa-Gevaert Inc., Teterboro, New Jersey; Matt Lehmann, Stanford Research Institute, Palo Alto, California; Emmett Leith, Radar and Optics Laboratory, University of Michigan; Jean-Claude Le Magny, Conservateur au Cabinet des Estampes, Bibliothèque Nationale, Paris; Robert Lohman, Optical Data Storage Research, RCA, Princeton, New Jersey; Dieter Lübeck, Cologne; L. Andrew Mannheim, Technical Editor of *Camera*, Lucerne; Edward F. Osborne, Abto Inc., New York City; Daniela Palazzoli, Milan; Allan Porter, Editor of *Camera*, Lucerne; George W. Stroke, Electro-Optical Sciences Center, State University of New York at Stony Brook; Howard Taylor, Stereo Optical Co., Chicago; Kenneth Tyler, Gemini Graphic Editions Ltd., Los Angeles; Marcello Venturoli, Soprintendenza alla Galleria Nazionale d'Arte Moderna, Rome; William Wilson, New York City; Augustus Wolfman, Editor of *The Wolfman Report*, New York City; Ralph Wuerker, TRW Inc., Redondo Beach, California.

Picture Credits
Credits from left to right are separated by semicolons, from top to bottom by dashes.

COVER—Tom Porett

Chapter 1: 11—Dr. Gerhard Nagel, Institut Baugeschichte/Abt. Architektur-Photogrammetrie der T.U. Stuttgart, courtesy Deutsche Verlags Anstalt-X Magazine. 12—© John Dille Co. 13—Marvin Koner for FORTUNE. 19—Dieter Lübeck, courtesy DVA. 20, 21—Dr. Erhard Borcke, Dr. Erwin Ranz, Agfa-Gevaert Technikum, Munich, courtesy DVA. 22—Professor Klaus Linkwitz, Hans Dieter Preuss, Institut für Geodäsie im Bauwesen der T.U. Stuttgart, courtesy DVA. 23—Dr. Gerhard Nagel, Institut Baugeschichte/Abt. Architektur-Photogrammetrie der T.U. Stuttgart, courtesy DVA. 24—Professor Wilhelm Waidelich, Dr. Franz Lanzl, Erstes Physikalisches Institut der T.U. Darmstadt. Hermann J. Mager, Gesellschaft für Strahlenforschung, und Umweltforschung und Erstes Physikalisches Institut der T.U. Darmstadt, courtesy DVA. 25—Direktor Paul Kassenbeck, Arthur Neukirchner, Jürgen Tochtenhagen, Fraunhofer Institut f. angew, Mikroskopie, Karlsruhe, courtesy DVA. 26—Professor Fritz Winckel, Dr. Manfred Krause, Lehrgebiet Kommunikationswissenschaft, T.U. Berlin, courtesy DVA. 27—Dr. John L. Dubois, James Electronics Inc., Chicago, courtesy DVA. 28—Professor Robert Müller, Dr. Rolf Kayser, Institut für Modellstatik der T.U. Stuttgart, courtesy DVA. 29—Dr. Dieter Völker, Hanseatische AGA, GmbH, Hamburg, courtesy DVA. 30—Kriminaldirektion Stuttgart, courtesy DVA.

Chapter 2: 33—Al Freni. 39—Asahi Optical Co., Ltd., except top left, Al Freni. 40—Courtesy Nikon House. 41—Courtesy Paillard House. 42, 43—Al Freni. 45—Diagram by Nicholas Fasciano. 46—Al Freni—diagram by Nicholas Fasciano. 47—Marc and Evelyne Bernheim from Rapho Guillumette. 48 through 51—Al Freni, except diagram on page 51, Nicholas Fasciano. 52—Diagram by Nicholas Fasciano—Al Freni; courtesy ABTO Inc.

Chapter 3: 55—George E. Obremski. 56—Al Freni. 63 through 76—Fred Burrell. 77—Silk-screen print by Roni Henning, based on a photograph by Fred Burrell, copied by Al Freni. 79—Bill McCartney. 80, 81—Joan Redmond. 82, 83—Lawrence Bach. 84—Nicholas Amplo. 85—Tom Porett. 86, 87—Barbara Blondeau. 88, 89—Joanne Leonard. 90, 91—Tom Porett. 92, 93—William G. Larson, courtesy Catherine Jansen. 94, 95—René Groebli. 96, 97—Eleanor Moty. 98—Naomi Savage.

Chapter 4: 101—Eric Pollitzer, courtesy William Wilson. 105—Richard Hamilton. 106, 107—Lithograph by Robert Rauschenberg, copied by Herb Orth, courtesy Association of American Artists. 108—Silk-screen by Andy Warhol, copied by Henry Groskinsky, courtesy Mr. Leon Kraushar. 109—Painting by Richard Hamilton, copied by Derek Bayes, courtesy Peter Stuyvesant Foundation. 110, 111—Painting by Giosetta Fioroni, copied by Fotostudio Max, courtesy Galleria del Cavallino, Venice. 112, 113—Collage by Michelangelo Pistoletto, copied by Aldo Durazzi, courtesy Galleria Nazionale d'Arte Moderna, Rome. 114, 115—Helmmo Kindermann. 116, 117—Construction by Lucas Samaras, copied by Nathan Rabin, courtesy Jon Streep. 118, 119—Just Jaeckin. 120—Dale L. Quarterman.

Chapter 5: 123—Matt Lehmann. 126 through 129—Al Freni. 130—Diagram by Nicholas Fasciano. 131 Diagram by Nicholas Fasciano; courtesy Stereo Optical Co. 132, 133—Dr. Eugene Trachtman—Ted Dully. 137—Diagram by Nicholas Fasciano. 138—Courtesy Bell Telephone Laboratories. 143—Dr. George W. Stroke. 147—Courtesy McDonnell Douglas Corp. 149—Fritz Goro. 151—*St. Louis Post-Dispatch* from Black Star. 152, 153—Harry Seawell for FORTUNE. 154—G. C. Optronics, Inc. 155—Harry Seawell for FORTUNE. 157—Courtesy RCA. 158—Diagram by Walter Hortens.

Chapter 6: 161—Erich Hartmann from Magnum. 162—Courtesy George Eastman House. 163—Arnold H. Crane Collection, Chicago. 165—Ernst Haas. 166—Harald Sund. 167—Ernst Haas. 168, 169—Pete Turner. 170—Stan Levy. 171—Harald Sund. 172—George E. Obremski. 173—Bill McCartney. 174, 175—Mitchell Funk. 176—Jay Maisel. 177—Alan Kaplan. 178, 179—Nob Fukuda from Photo Trends. 180, 181—Bill Longcore. 182—Harald Sund. 183—Al Lunt. 184, 185—George E. Obremski. 186—Len Gittleman. 187—Stephen Allen Whealton, courtesy Edmund Scientific Co. 188, 189—Stephen Green-Armytage. 190, 191—Bill McCartney. 192—Michael Heller. 193—Dr. Elsa Garmire. 194, 195—Jack Kath from Photo Trends. 196—Paul Cords.

Index

Numerals in italics indicate a photograph, painting or drawing of the subject mentioned.